IMAGES
of America

ABINGTON, JENKINTOWN, AND ROCKLEDGE

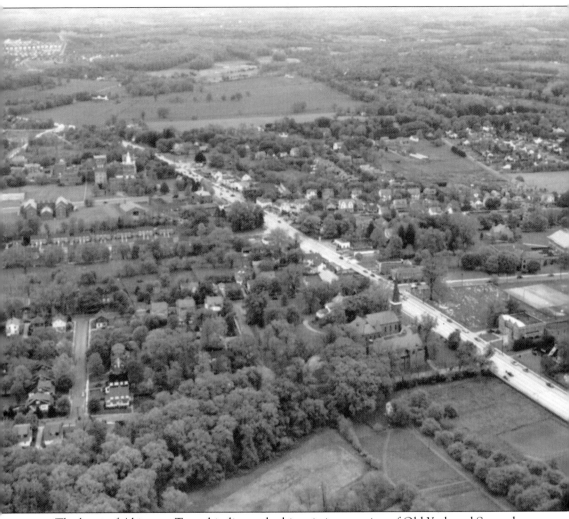

The heart of Abington Township lies at the historic intersection of Old York and Susquehanna Roads. Since the early 1700s, people have traveled these routes regardless of how the landscape has changed. Taken in the 1940s, this view looks northeast over the center of Abington. On Old York Road, the building that today houses the Abington Free Library has not yet been built, nor have the houses behind it on Church Street and Old Orchard Road (1955). The Abington Presbyterian Church has yet to expand (1957 and 1959), Abington Hospital is only a small facility relative to what it is today, the Abington School District bus depot has yet to be built on Huntingdon Road (1951), and the Abington Shopping Center and the Brentwood housing development have not yet overrun the farm once owned by George Elkins (1954–1955). Despite the changes to come, however, the area is identifiable. Many of the residential houses captured in the photograph still remain. Landmarks such as the church, the YMCA, and the hospital still anchor the scene, giving a sense of place that, while always changing, reminds us of what once was.

IMAGES
of America

ABINGTON, JENKINTOWN, AND ROCKLEDGE

Old York Road Historical Society

ARCADIA
PUBLISHING

Published by Arcadia Publishing
Charleston, South Carolina

Printed in the United States of America

Library of Congress Catalog Card Number: 00105709

For all general information contact Arcadia Publishing at:
Telephone 843-853-2070
Fax 843-853-0044
E-mail sales@arcadiapublishing.com
For customer service and orders:
Toll-Free 1-888-313-2665

Visit us on the Internet at www.arcadiapublishing.com

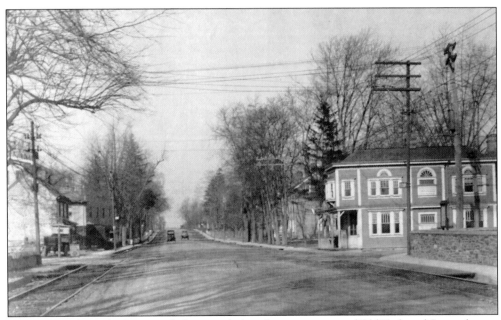

In this *c.* 1915 view looking north from just below the intersection of Old York and Susquehanna Roads in the center of Abington, the growing prosperity of the community is evident in the widened road, the trolley tracks on both sides of the street, the electrical wires running overhead, and the automobiles. The northwestern corner of the Abington Church cemetery wall is captured at the right corner along with the tollhouse and the Rex house beyond it. On the west side of Old York Road, the site of the blacksmith shop is cleared, anticipating the construction of Powell's Pharmacy. Other 18th-century houses still stand along the road.

CONTENTS

PREFACE

The Old York Road Historical Society was formed in 1936 to study and perpetuate the history and folklore of the communities along and adjacent to the Old York Road from Rising Sun in Philadelphia to New Hope in Bucks County. Over the years, the Old York Road Historical Society has offered a wide variety of programs and scholarly publications covering this area. Its collections are focused primarily on the communities in eastern Montgomery County, specifically the townships of Abington, Cheltenham, Lower Moreland, and Upper Moreland and the boroughs of Bryn Athyn, Hatboro, Jenkintown, and Rockledge. The Old York Road Historical Society's archive of historical materials related to this area is unsurpassed in volume and breadth. Included are some 40,000 photographic images, a few of which have been carefully selected for this book.

The Old York Road Historical Society remains committed to being the best local history research facility with the best collections for the communities it serves. To that end, the Old York Road Historical Society is interested in both sharing the materials in its collections as well as augmenting its collections with additional materials. This book helps fulfill that goal. In addition to *Abington, Jenkintown, and Rockledge*, the Old York Road Historical Society plans to work with Arcadia Publishing to issue two additional books covering the remaining communities in eastern Montgomery County, namely Cheltenham Township and the townships and boroughs that comprise what was originally the Manor of Moreland.

With regard to enhancing its collections, the Old York Road Historical Society is always interested in receiving materials that relate to the local area. From photographs and postcards to business records and family manuscripts, we are able to offer the communities we serve an impressive collection thanks to the generosity of those who have made donations in the past. Any additions you can make to our collections will be well cared for and most appreciated.

Please visit the Old York Road Historical Society on the web at www.oyrhs.org or on the lower level of the Jenkintown Library. The archive is open to the public on Monday evenings from 7 to 9 p.m., Tuesdays from 11 a.m. to 2 p.m., Wednesdays from 11 a.m. to 3 p.m., or by appointment. You may telephone us at 215-886-8590. We hope you enjoy this book and we thank you for your support.

INTRODUCTION

The present-day political boundaries of Abington Township and the boroughs of Jenkintown and Rockledge prove rather limiting when attempting to understand the history of our common area. Before first-class township status came to Abington Township (1906), before Rockledge became a borough (1893), before Jenkintown became a borough (1874), and before Montgomery County was divided from Philadelphia County (1784), the area was simply known as Abington Township. On the earliest maps, the area was identified as Second or Middle Dublin, with First or Lower Dublin becoming the Bustleton area of Philadelphia, and Third or Upper Dublin surviving to the present day with its original name.

When William Penn came to Pennsylvania in the early 1680s, the region was populated with only a few hardy settlers along the Delaware River, primarily of Swedish descent. With Penn's arrival, the process of granting land and settling the area began in earnest, an activity primarily fueled by English and Welsh settlers. By 1684 the lower portion of Abington Township was in private hands and, by the end of the decade, all of the land in Abington Township had been granted. In 1687 the Abington Monthly Meeting was organized as an extension of the Oxford Monthly Meeting. With landowners came the beginnings of settlements. Forests were cleared, farms were established, and roads were laid out.

Old York Road was the first of the three major north-south arteries in the township (the other two being Easton Road and Huntingdon Pike). Laid out in 1711, Old York Road followed the line of a Native American path through the forest. It would be several years before it ran as a clear lane and many more before it would become the major artery it is today.

In the days of travel when the fastest anyone could dream of moving was by the speed of a horse, Jenkintown grew as a major stop on the road to New York. Inns were established and commerce was transacted. Travel brought development. Villages in the area on the roads less traveled did not become as vital or as prosperous as those on the main thoroughfares. Turnpike companies were established by shareholders to keep the main roads in good order. Old York Road was a toll road as early as 1804. Huntingdon Pike (originally Second Street Pike) came under private control in 1846, and Easton Road (also known as the Germantown and Willow Grove Turnpike or Plank Road) came under private control in 1852. The turnpike companies charged a fare to all passing traffic and were responsible for maintaining the roads.

While improved roads allowed for greater stage traffic, it was the coming of the train that opened vast acres of farmland for residential development. Long before it was commonplace for everyone to live in the suburbs and take vacations, most non-farming people lived in the

city. Philadelphia was the largest city in the country until 1820, and only the very wealthiest of its citizenry were able to escape to the country. With the advent of the train, people were able to travel to the city during the day and sleep at home in the country at night. The first train through the area came in 1855, connecting Philadelphia with Gwynedd through Glenside and, in 1859, Jenkintown. In 1875 the Philadelphia-to-Newtown line was completed. In 1876 the Bound Brook line (now SEPTA's West Trenton line) became a branch from Jenkintown.

Development radiated from the train stations along the way. Whether it was mansions for the very wealthy, single detached homes for the growing middle class, or row homes for the working class, the railroads initiated the transformation of farmland to suburbs. Prior to the second half of the 19th century, when the first residential building boom started, the towns and villages in Abington Township were distinct places. There was a sense of a town center—a small cluster of homes and businesses dotted the landscape here and there—in what was otherwise open country. Each town had its own general store with a post office and, in time, each settled upon its own name.

As society grew more sophisticated and complex, so did its institutions. Before 1840, all schooling was done privately. After the adoption of the Common School System by the township, public schooling took root, although not without opposition. Governmental organizations also developed. Although incorporated in 1794, Abington Township had little government other than for collecting taxes. It was not until the 20th century, when Abington became a first-class township, that a governmental organization took hold. Jenkintown (in 1874) and Rockledge (in 1893) each petitioned the state legislature for separate status and each became an independent borough. Although Meadowbrook (in 1927) and Glenside (in 1905 and 1938) attempted the same maneuver, Abington's government proved sufficient.

As the prosperity of the region grew, the development of the land for residential use soared. W.T.B. Roberts in Glenside and the Herkness family in Meadowbrook and Rydal were the leaders in developing the land, albeit for varying types of clientele. Farms were purchased, streets laid out, and homes built. In 1895 the electric trolley came to Willow Grove, and an amusement park was born. Housing developments in Roslyn and Crestmont followed those in Glenside and Ardsley.

If the 18th century transformed a forested wilderness into an agrarian landscape and the 19th century transformed the land with the infrastructure of a diverse society, the 20th century completed the transformation to suburbia writ large. The advent of the automobile expanded the horizons. By 1920 the toll roads were freed by the state. After a slow decline, the trolley cars stopped running in 1940. The greatest change, however, occurred after World War II. The desire for, and the financial feasibility of, suburban living erased the agrarian vestiges of earlier times. Farm after farm was developed in the 1950s, and the distances and distinctions that separated one village from the next completely disappeared.

While the boundaries that separate Abington Township, Jenkintown, and Rockledge from each other are very distinct in how we think about each of the communities, the history that we share is from a common thread. The trends that shaped the communities into what they are today are the same. The histories of Abington, Jenkintown, and Rockledge are fascinating for that very reason.

This briefest of histories is intended as a broad overview of the forces that have shaped our community. Greater detail can be found in a multiplicity of sources, all contained in the Old York Road Historical Society's substantial research collection. The photographs that follow are but a glimpse into the rich and varied history of Abington Township, Jenkintown, and Rockledge. There is much more than what we have been able to include here. Regardless, it is our hope that the photographs and accompanying text will give each and every reader enough material to understand and enjoy our common history a bit more than before. In fact, it might be that such a book will spark you to delve deeper into our past.

—David B. Rowland, President
Old York Road Historical Society

One

JENKINTOWN

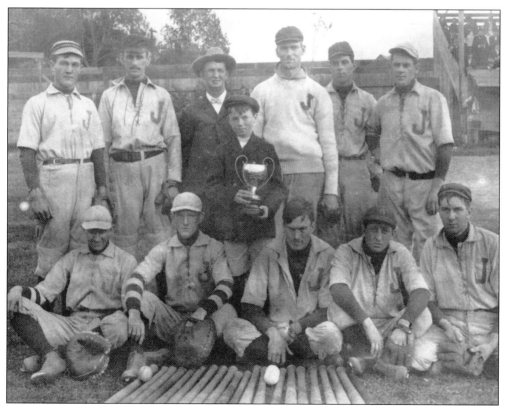

Members of the Jenkintown baseball team pose proudly with the trophy they won for being the 1904 Suburban League champions. Identifiable last names of some of the team members include Richardson, Clemmer, Freeland, Hunter, and Harper.

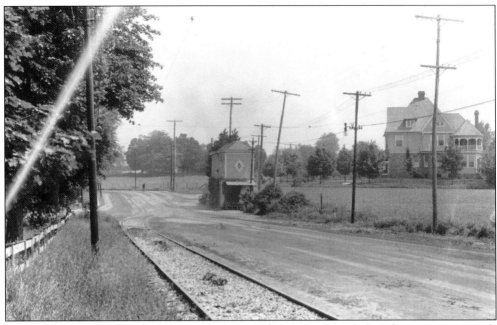

Approaching Jenkintown from the south along Old York Road just below the intersection with Washington Lane, this tollhouse stood at the southeast corner. The trolley tracks ran along the side of Old York Road, except in Jenkintown, where they ran down the center of the street. This house on Washington Lane is still standing. The photograph dates from May 1907.

AN ORDINANCE

To prohibit the erection of any slaughter house, or the carrying on of any manufacture, art, trade or business which may be noxious or offensive to the inhabitants of the Borough of JENKINTOWN.

SECTION 1. Be it ordained and enacted by the Town Council assembled, and it is hereby enacted by the authority of the same that hereafter, it shall be unlawful for any person or persons to erect or cause to be put up, any slaughter house or any building to be used for the killing or slaughtering of any animal; either steer, cow, swine or sheep, or for the keeping of any offal whatsoever, within the limits of said Borough; without the consent of Council being first had and obtained at their regular stated meeting.

SECTION 2. And be it further enacted that no pig pens, cess pools, sinks, or drains, shall be erected, or placed on any street, lane, road or other highway, within fifty (50) feet of said streets or highway, (provided that no cess pool shall be in depth less than five (5) feet), and that any pig pen, cess pool, sink, drain or manufacture, art, trade or business which may be noxious or offensive to the inhabitants of said Borough, located on the line of any public street or other highway, shall be at once removed or taken down in accordance with this act.

SECTION 3. And be it further enacted by authority of the same, that if any person or persons refuse or neglect to remove any such nuisances or offensive matter, whether in the public highway or private grounds, the corporation may cause the same to be done, and collect the cost thereof, with twenty per centum advance thereon in the manner provided for the costs of pavements made by the corporation.

CHARLES COTTMAN, President.

ATTEST—JOHN J. C. HARVEY, Secretary.

Approved, the Seventh day of November, A. D., 1878.

THOS. P. MANYPENNY, Burgess.

When Jenkintown became a borough in December 1874, the first ordinances dealt with the necessary rules and regulations involved in setting up and operating a government. Later ordinances banned driving vehicles or riding horses or mules on the sidewalks and the throwing of dirt, garbage, and other offal. These ordinances were meant to improve the everyday quality of life for the borough's citizens.

The R.J. Mitchell house, pictured in January 1897, stood as late as 1947 on Old York Road, north of Washington Lane. The next house up York Road was at the southwest corner of Summit Avenue. The building with the conical tower was at the southwest corner of Greenwood Avenue and was razed for the 1907 construction of the Jenkintown Club and Reading Room (later the Center Building).

This view from the early 1950s shows the same house still at the corner of Summit Avenue, but the A&P supermarket and its parking lot have replaced the Mitchell house. A three-story stone building now occupies the front lawn of the large house on the northwest corner of Summit Avenue.

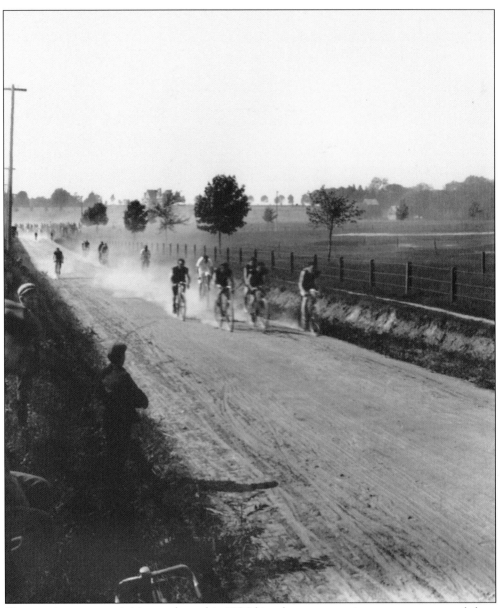

Community sports activities, such as this 1896 bicycle race, were important events and drew large crowds. This view, looking east on Washington Lane from Heger's Corner (Greenwood Avenue), vividly shows the furious pace of the cyclists. The land along the south side of Washington Lane is owned by the Abington Friends Meeting.

C.F. Wilson built this house at the northwest corner of Summit Avenue and Old York Road in 1894. It is still in existence, although hidden and much altered. The Philadelphia Suburban Gas and Electric Company built a one-story building in front of the house in 1917 and added two more stories to it in 1924, building into the house. The water tower was located on the lot bounded by Willow, Leedom, and Water Streets. The tower was taken down and sent to Fort Dix in 1917. This photograph is dated January 1897.

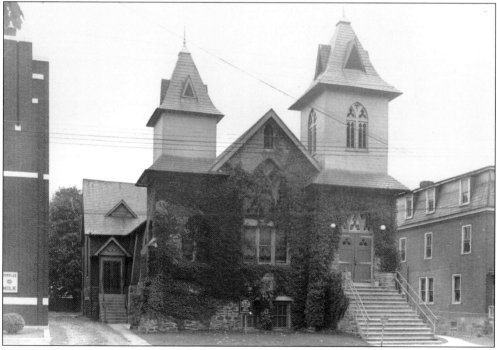

The first home of the Salem Baptist Church from 1897 to 1907 was a small frame building. In 1909 this stone and brick building replaced it at the same site on Summit Avenue facing Leedom Street. The church was organized in 1884 and met in a private home at 506 Division Street and then at the lyceum before construction of the first church building. The second building was replaced in 1957, again at the same site.

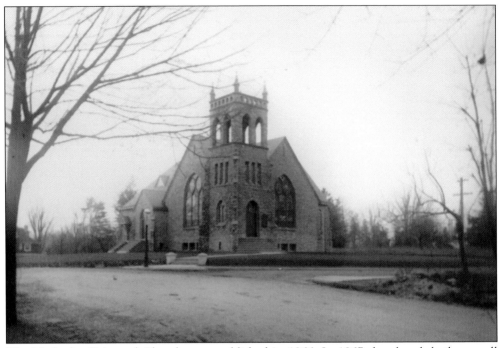

The Methodist Episcopal Church was established in 1866. In 1867 the church built a small building on the foundations of the 1842 schoolhouse at the southwest corner of Leedom Street and West Avenue. In 1902 the church built a new building at the southwest corner of Summit Avenue and Walnut Street, as shown in this photograph from December 1903.

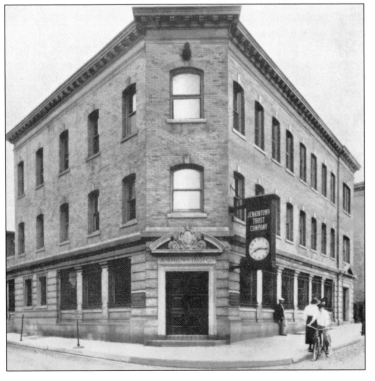

The Jenkintown Trust Company building is shown sometime between December 1915 and 1922, when the company merged with the Jenkintown National Bank. The Trust Company, founded in 1903, moved into the remodeled George Fleck home and store at the northwest corner of Old York Road and Greenwood Avenue in November 1904. In 1906 the building was enlarged after purchasing and razing the Christie home immediately to the north.

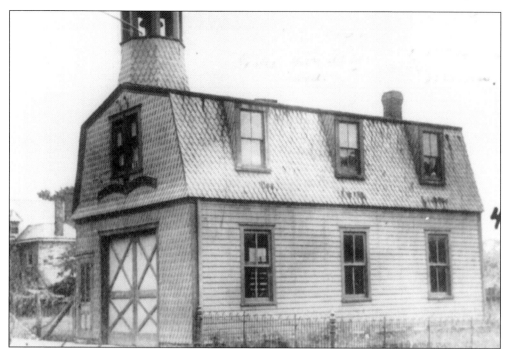

The first home of the Pioneer Fire Company No. 1 was built in 1884 by W.H. Thomas on the south side of Greenwood Avenue, midway between Old York Road and Leedom Street. Sometime after the company moved to its current building in 1906, the structure was moved to a location at Leedom Street and Summit Avenue. The company was formed in 1884.

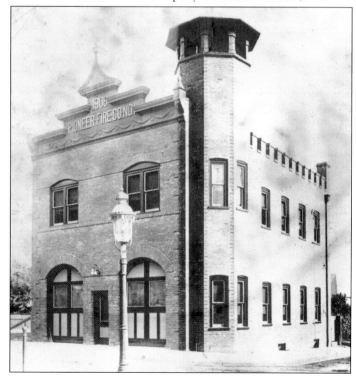

The second home of the Pioneer Fire Company, located at the southeast corner of Greenwood Avenue and Leedom Street, is still in use, but has been remodeled and modernized since it was first occupied in 1906.

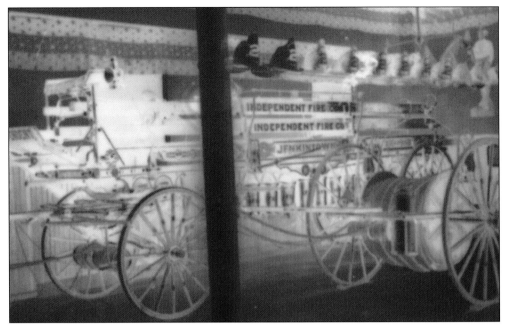

The home of Independent Fire Company No. 2 is at 609 Greenwood Avenue. The company was founded in 1889. This very early view of an old hose carriage was taken inside the firehouse.

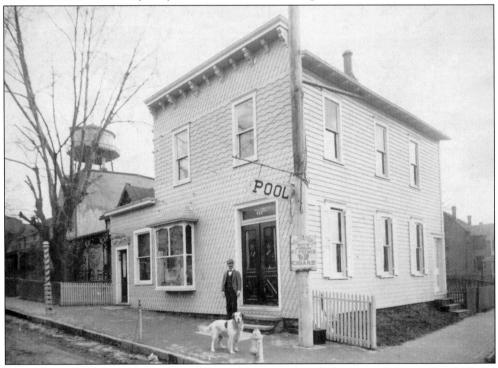

The Clayton store was located at the southeast corner of Greenwood Avenue and Cedar Street. The first early movies were shown in a pool hall on the second floor. The structure was remodeled later, with a third floor and new roofline added. It was the home of the Fleck Company Machine Division before becoming the home of Stutz Candies.

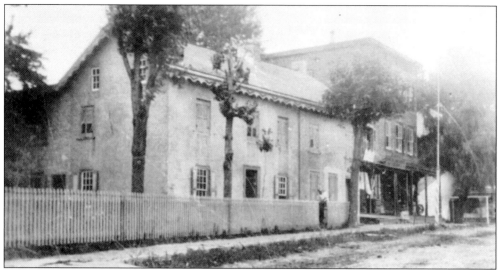

The Harry N. Christie house was north of Greenwood Avenue on the west side of Old York Road. The house, built in the 1790s by William Webster, was later sold to Joseph Heacock and then to Benjamin Fleck. It was razed in 1906 for the northern expansion of the Jenkintown Trust Company. The light-colored building at the extreme right is the Jenkintown House Inn at the southwest corner of West Avenue.

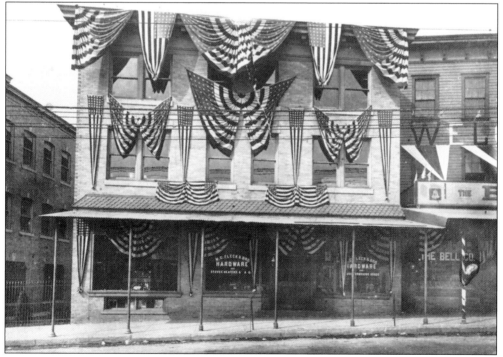

W.C. Fleck & Brother Hardware, located at 309 Old York Road, is decorated for the World War I homecoming celebration in November 1919. The store was established at this location in 1872. It continued here until May 1948, when Fleck announced it was leaving the hardware business and concentrating on machine manufacturing. However, a Fleck hardware store remained in Jenkintown under different ownership at another location.

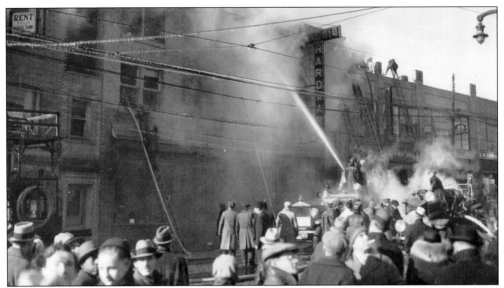

The disastrous Fleck Hardware fire occurred in December 1933 and threatened the whole business block between West and Greenwood Avenues. More than a dozen fire companies battled the blaze. Immediately to the right are the F.W. Woolworth Company store, Goldberg's Department Store, and the L.W. Oswald Pharmacy. Fleck rebuilt the store in the Art Deco style.

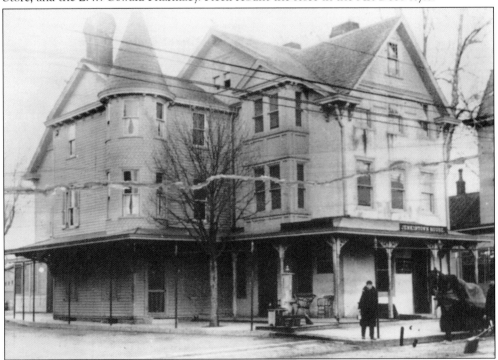

The Jenkintown House, on the southwest corner of Old York Road and West Avenue, was also known by its various owners' names over its long history. The original structure became part of an enlarged building, shown here in 1897, and can be traced back to 1773. The building became an inn between 1840 and 1850 and was known as the Phoenix Hotel. It was razed c. 1930 for an American Company grocery store.

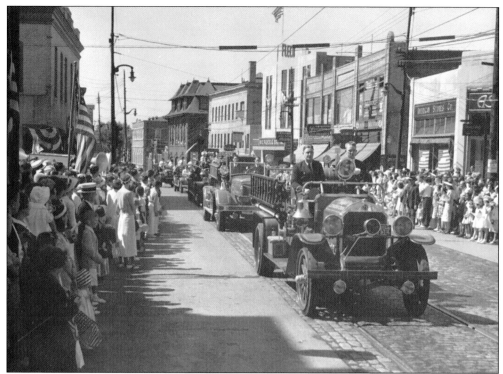

The Independent Fire Company leads the 1938 Fourth of July parade as it passes by the 300 block of the west side of Old York Road. Looking south, the American Company store is at the corner of West Avenue, followed by the L.W. Oswald Pharmacy, Goldberg's Department Store, F.W. Woolworth, W.C. Fleck, and the Felbin Building, which housed the Liberty Market and was formerly the old Jenkintown Trust Company building.

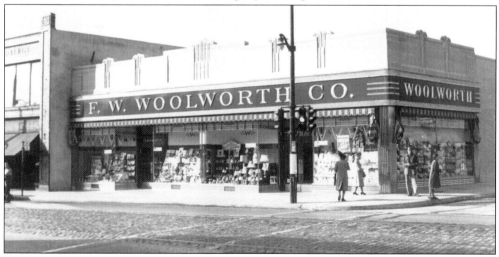

The F.W. Woolworth Company store on the southwest corner of West Avenue and Old York Road replaced the old American Company store and the old Oswald store in 1948. It remained at this location until it closed in the early 1980s. The building was remodeled shortly thereafter for a series of small shops, and in 2000 was remodeled again back to a single store, this time uncovering portions of the original design.

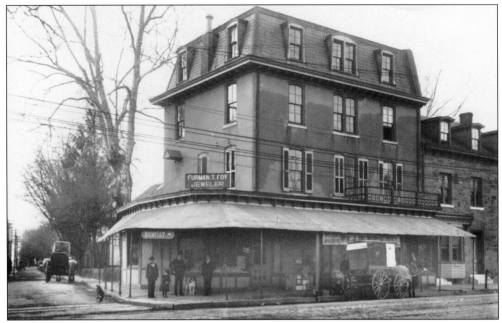

The Foy building, at the northwest corner of West Avenue and Old York Road, is shown as it looked *c.* 1905. This corner had a store on it as early as 1800; the Harper Store was the occupant in the 1880s, and Furman Foy and Samuel Diehl bought the corner in 1891. Shown here are Foy's Jewelry, the William Dillworth store, and Miss McMullan's Notion Shop. The property was bought by L.W. Oswald in 1940 and was demolished in 1946 for the new Oswald Pharmacy. The house on the right was occupied by several different doctors until 1917, when it became incorporated into the new and larger McDonnell's Pharmacy at 407–409 Old York Road.

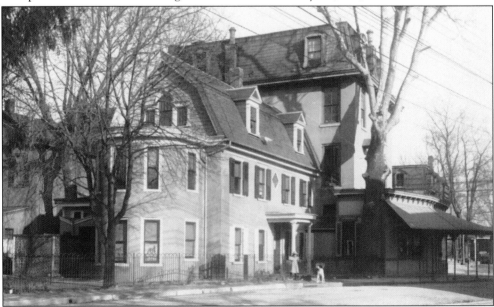

This West Avenue house was immediately behind and part of the Foy building. It was the home of the Harpers and then the Foys until it was razed and replaced by a large commercial building. This picture dates from the early 1900s.

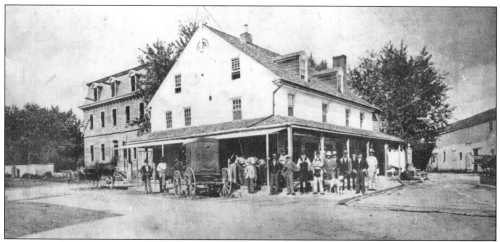

The Sarah Jenkins Inn, also known as the Eagle or American Eagle Inn, was built in 1725. The Cottman family bought the inn from Daniel Strawn in 1834, and it became the first Cottman House, although it was still known by its earlier names. In this c. 1879 photograph, the new Cottman House is shown under construction in the background. The older inn was demolished shortly after the new Cottman House was completed. The inn was in the center of the current eastern extension of West Avenue and extended into the Old York Road intersection.

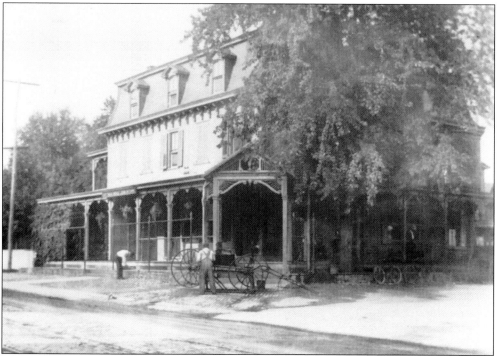

This photograph of the Cottman House dates from August 1896, when the owner was J. Frank Cottman. This inn and the Jenkintown House, diagonally across Old York Road, were the two largest and most popular public houses in the area; they featured electric lighting and steam heat. The site was bought by the Jenkintown Bank & Trust Company in January 1923 and was cleared for the construction of the bank's new building, which still stands at the northeast corner of Old York Road and West Avenue.

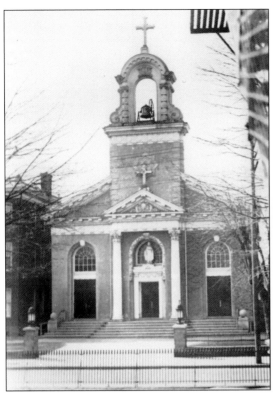

Construction of the original Immaculate Conception Roman Catholic Church began in 1866; the building was dedicated in July 1868. It was completely destroyed by fire in February 1928, despite the efforts of more than 14 fire companies. Work began almost immediately on a new building, which was dedicated in September 1929.

Immediately behind the Immaculate Conception church, at the northeast corner of Cedar Street and Greenwood Avenue, was the parish school. The original 1895 building included only the one-story stone portion; the second floor was added later. The building was razed in 1967 upon the completion of the new parish school on West Avenue.

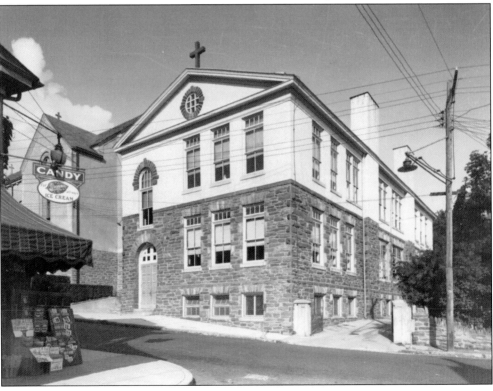

The impetus for the founding of the Jenkintown Day Nursery came from Mrs. Theodore B. Culver, who felt the need for a place where small children could be cared for while their mothers worked. As a result, the nursery was organized in February 1903, with all the furnishings contributed by friends. In October 1903, the nursery moved to quarters at Thomas and Water Streets, where it remained until it moved to larger quarters on Baeder Road in the mid-1960s. This picnic was photographed on May 15, 1947.

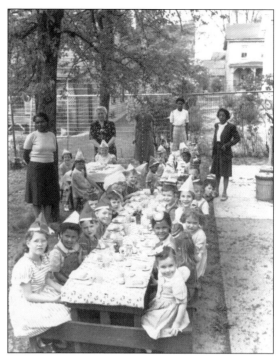

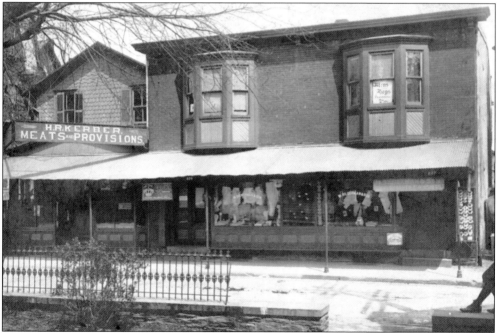

Directly opposite the Immaculate Conception church on West Avenue were the sites of the H.R. Kerber Meats and Provisions and M. Silberman & Son stores at Nos. 603, 605, and 607. Kerber and Lutz bought the frame building in 1894 from Samuel Aiman, who was the first butcher to open a store devoted to meats only. The odor was a problem to the school next-door, despite the high board fence dividing the properties. The building was razed later, but the brick building is still in existence and is now numbered 603–605.

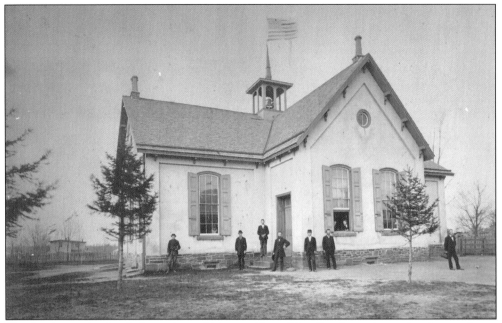

The first borough school, formerly an Abington Township school, was located at the northeast corner of West Avenue and Cedar Street. This photograph was taken in May 1876 and appeared in the *Jenkintown Pestle* before it was exhibited at the Centennial in Philadelphia. Shown in the picture are Principal Enos W. Rosenberger (at the foot of the steps with a hat in hand); his daughter, Mattie Rosenberger, and Archanna Prince, both teachers (at the window); and George Kohl, a school director (extreme right). Others seen here include George McCool, George Nice, Edward Everett, George Fleck, and Francis Triol.

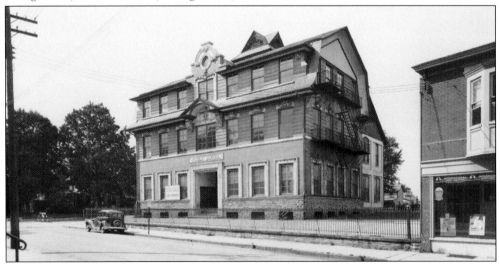

In 1904 a modern building employing the very latest in school design was added to the front of the Jenkintown School. The older school, now enlarged and with a second floor, can be seen behind the 1904 building. Despite construction of a separate high school building in 1924, this building had become badly overcrowded by the 1930s. After a serious fire in 1935, a new grade school was built next to the high school and opened in 1937. These two buildings were demolished in 1939, when the federal government bought the site for a new post office.

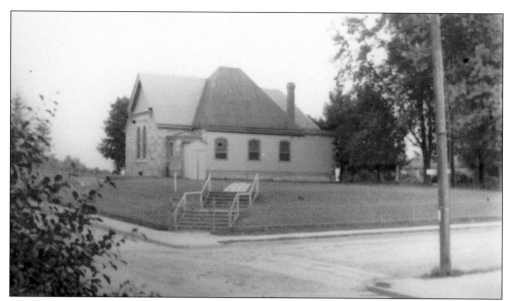

The Jenkintown Baptist Church, organized in 1880, constructed its church building on the southwest corner of Walnut Street and West Avenue. This is a very early photograph, dating from June 1899, before the final front was added. The congregation merged with the Tioga Baptist Church c. 1960 and took the name Abington Baptist Church. Members continued to hold services in Jenkintown until a new building was dedicated in Abington in March 1963. The Jenkintown High School tennis courts are now at the site.

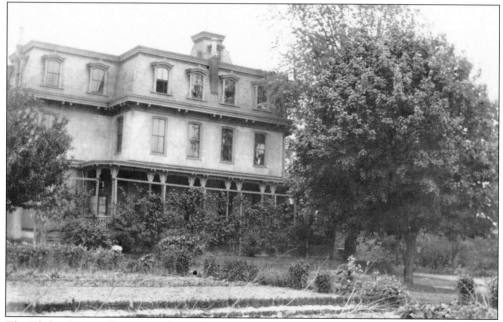

The Philip Spaeter home was located with its back to the future West Avenue on a large lot facing Spaeter (later Highland) Avenue, which is now the site of the Jenkintown High School. When Spaeter, a cooper in Philadelphia, bought the land from Joseph Stulb in 1877, he tore down an older house to build his new home. The Jenkintown School Board bought the land, and the house was demolished in the early 1920s.

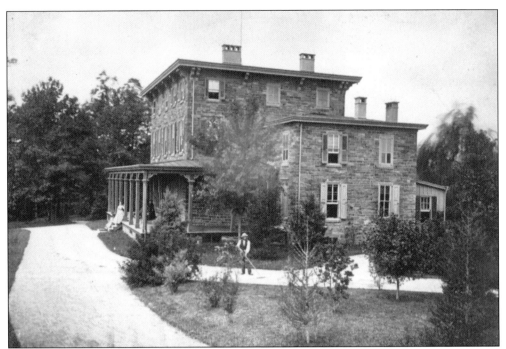

William C. Kent, a mill owner during and after the Civil War, was credited with inventing the trading in cotton futures. In 1854 he bought 103 acres of land straddling the Abington-Cheltenham boundary and built Beechwood. It stood at the top of the hill facing Greenwood Avenue near the Jenkintown train station. Kent gave a piece of his front lawn for the construction of the new station in 1872 and was given passenger ticket No. 1 from Philadelphia to Jenkintown. Financial reverses brought about the sale of the house and land soon thereafter.

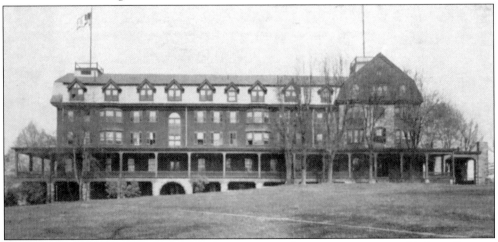

The Beechwood Inn opened in 1877 after a massive four-story wing was added to the west side of the original house. For many years, it was a very successful summer hotel. In October 1912 the inn became the Beechwood School for Young Ladies and was enlarged in 1913 with the addition of more classrooms and a chapel. The property was purchased in 1925 by Beaver College to serve as its newly transplanted campus. When Beaver College consolidated its two campuses at Glenside in 1962, the property was sold. Shortly thereafter the whole area was razed for the construction of the Beaver Hill apartments.

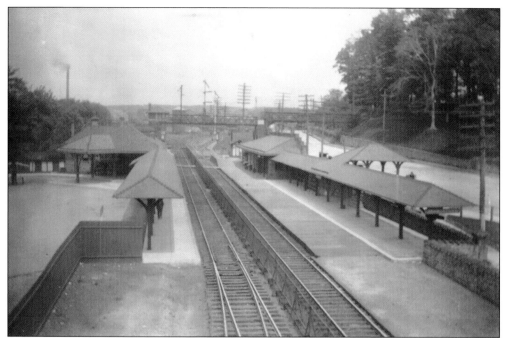

The old Jenkintown station, built in 1872 and shown here in July 1906, served the area's rail transportation needs until a new Horace Trumbauer building replaced it in 1932. The pedestrian steps and bridges from both inbound and outbound sides of the tracks crossed over West Avenue and led directly to the Beechwood Inn at the top of the hill.

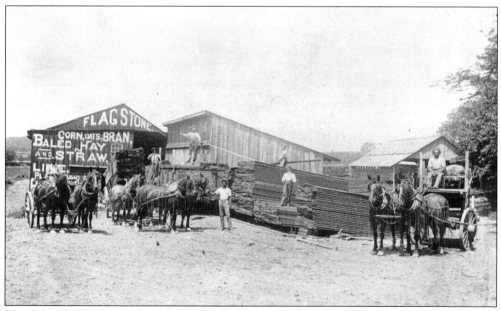

The Schively Lumber Yard was located at the curve on West Avenue next to the railroad tracks. It was originally owned by A. Jackson Smith and Samuel Shively. An 1898 advertisement described them as "dealers in coal, lumber, kindling wood, curb and paving stone, lime, plaster hair, cement, and bar-sand, etc." It was largely destroyed by fire in December 1930.

Before its move to West Avenue and Cedar Street, the post office occupied the far left end of this building on Johnson Street. It had previously been located in the Center Building at Old York Road and Greenwood Avenue. The Times Chronicle moved to this modern building in 1928, and a bowling alley occupied the second floor. The building on the far right was owned by the Women's Exchange, which was founded in 1932 and closed in 1996.

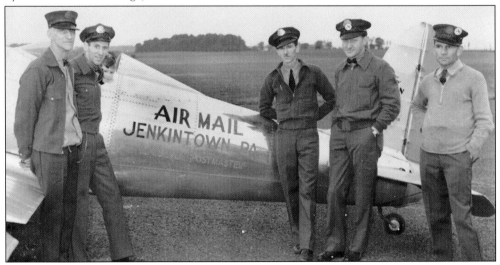

Postmaster B.A. Devlin was chairman of the Seventeenth Congressional District's Committee for the observation of National Air Mail Week, May 15–21, 1938. Special stamps were sold featuring images of Abington, Jenkintown, and Rydal. This Ryan monoplane made a special flight from Pitcairn Field in Horsham to pick up commemorative cancellations from the Jenkintown Post Office. Shown, from left to right, are Lou Zanine Sr., Frank Lockman, Jackie Devlin (son of the postmaster), Bill Ferguson, Dick Bolger, and Raymond Scott.

The first Jenkintown National Bank building stood approximately where Yorkway Place is today. The bank was founded in 1875 by a group of local storekeepers and farmers. This first building dated from 1880 and stood until 1908, when a completely rebuilt structure with a modern façade took its place.

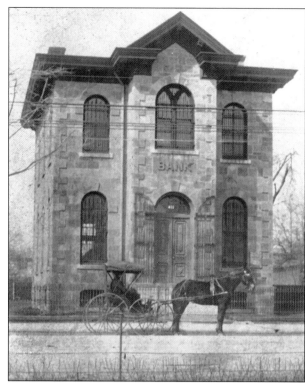

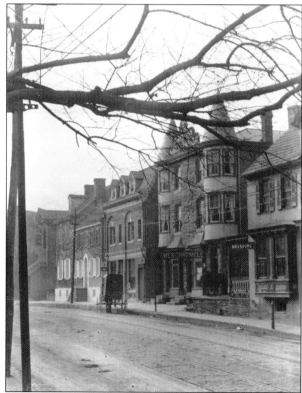

This c. 1904–1908 view of the west side of Old York Road shows the building the Times Chronicle occupied in 1897; J.F. McDonnell's first modern drugstore, built in 1904; the original Jesse Jenkins home, which served as home and office for a series of doctors; and the first Jenkintown National Bank building before its 1908 rebuilding. The store on the right had various occupants over the years and was Morris Goldberg's first store on Old York Road.

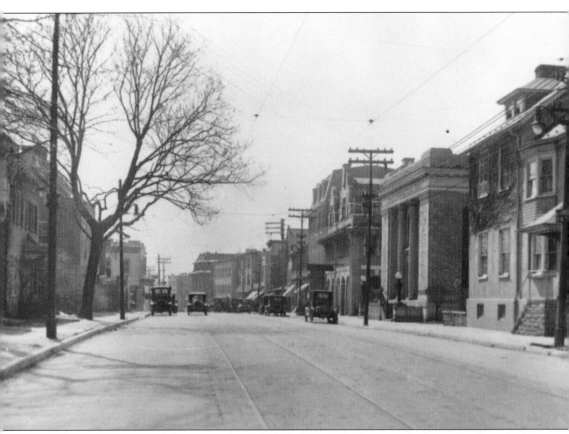

This c. 1920 view of the west side of Old York Road looking south shows the Jesse Jenkins house at the right. The house was built in the late 18th century and was the birthplace of Mary Jenkins Ross, a founder of the Jenkinstown Lyceum. Later, the house served as home and office for a series of doctors, including Doctors Betts, Paxson, Tyson, Walton, and Shoemaker. The building was demolished in the mid-1920s. To the south is the enlarged Jenkintown National Bank with its new façade; it was completed in 1908 and occupied by the bank until its merger with the Jenkintown Trust Company in 1922. The building was razed shortly thereafter for the construction of Yorkway Place. Farther south is McDonnell Drug Store's unusual new home at 407–409 York Road. Designed by Frederick Furbish and opened in 1917, the building was the most modern in Jenkintown for many years; it still stands. The drugstore was the largest independent pharmacy in the suburban area and continued to operate until December 1941.

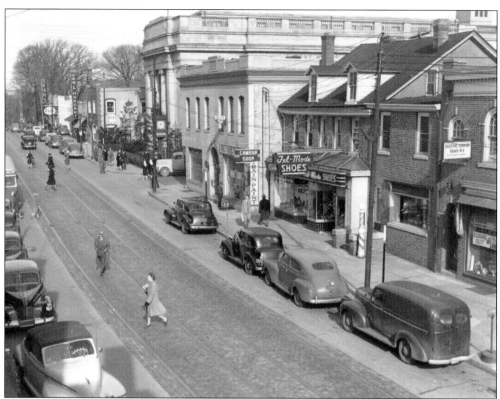

The Trank building, located at the southeast corner of West Avenue and Old York Road, was built c. 1900–1907 by realtor Joseph G. Trank. The 1925 Jenkintown Bank & Trust Company building is on the northeast corner, followed by Tomlinson Ford (with Tomlinson Realty on the second floor), the 1930 double storefront of Horn and Hardart (previously the first home of Sears), the Esso station, and the late-1930s, new and larger Sears store at the southeast corner of Homestead Road. This photograph dates from 1947.

The first church building in Jenkintown was the Episcopal Church of Our Saviour, located on the northeast corner of Old York and Homestead Roads; it was completed in June 1858. William H. Newbold gave the money to build the church as a thank offering for the sparing of his and his daughter's life in a serious train accident in 1855. The congregation was organized by E.Y. Buchanan, brother of President Buchanan. The first rector was Orme B. Kieth.

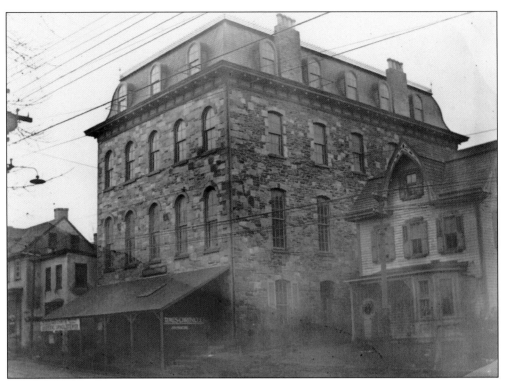

The Friendship Lodge of the Free and Accepted Masons, No. 400, was established in Jenkintown in 1867. The Masonic Hall was built in 1872–1873. It was the first home of the Times Chronicle, founded in 1894. A 1912 remodeling completely modernized the appearance of the building. This photograph dates from c. 1894–1897.

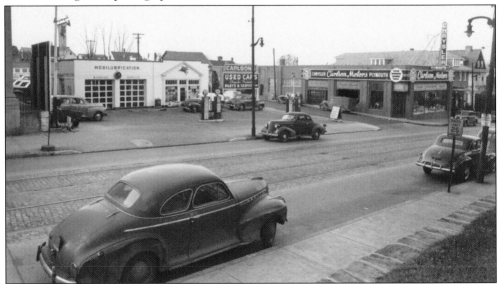

The site north of the Masonic Hall is shown in the late 1940s. The Mobil station replaced two houses owned by the Comfort and Dern families. The Carlson dealership was built on the site of a stone double house demolished in 1926. The auto dealership building was razed in 1977 to provide parking for the Helweg Funeral Home, located immediately to the north.

The Jenkintown trolley freight station, shown in August 1910, was located behind the current 463 Old York Road. The homes in the background are located on Leedom Street, since Johnson Street had not yet been cut through. The station was reached by a driveway on the north side of No. 463 and was demolished in 1923.

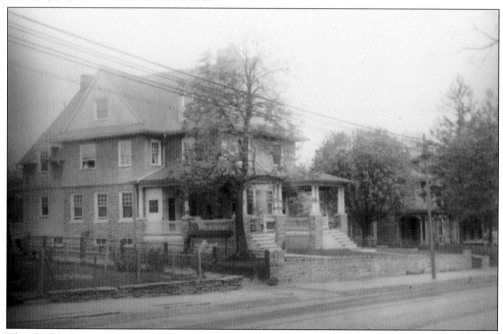

The double house at 469–473 Old York Road is shown here shortly after it was built in 1906. The north side served as the first manse for Grace Presbyterian Church and much later as a home for the Jenkintown Music School. The house is still on the site, now behind Mom's Bake at Home Pizza.

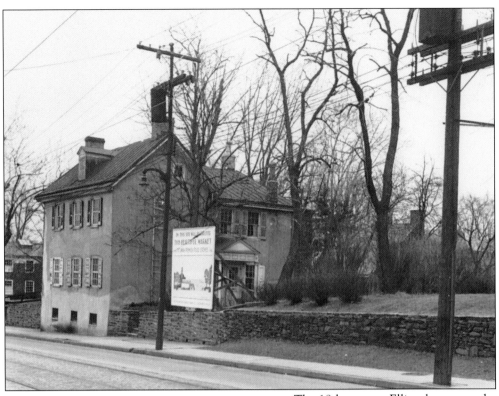

The 18th-century Elliott house stood at 440 Old York Road and was one of the oldest houses in the borough. In 1839, it was the home of Mary Jenkins Ross, who was a founder of the Jenkinstown Lyceum; the house was later owned by Jarvis Elliott. The building was razed in 1938, replaced by a Food Fair, then by T-Bird Bowling. Summersgate currently occupies the site.

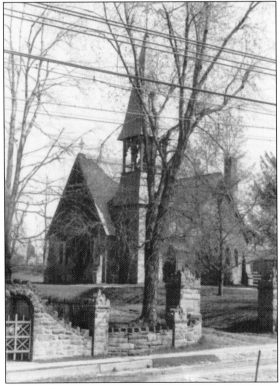

The Grace Presbyterian Church is shown c. April 1905. Vista Road has not yet been opened. Services had been held as early as 1845 in the Jenkinstown Lyceum, with the Rev. Robert Steel of Abington Presbyterian preaching. Abington Presbyterian bought land from John H. Newbold, and John Wanamaker built Grace Chapel at his own expense in 1869, in memory of his daughter, Harriet. In 1881 Grace Chapel separated from the parent Abington Church and became Grace Presbyterian.

The Jenkinstown Lyceum is shown here as it appeared in January 1907. Founded in 1838, it was a community cultural, educational, and social organization. Mary Jenkins Ross was a founding member and donated the land for the small building. The group was very active for many years, but never fully recovered from a division over the slavery issue in the 1860s. The small building gradually fell into disrepair and was ultimately purchased in 1909 by the Abington Library Society. The library added a large reading room in 1910, and a very generous bequest by John Lambert enabled the library to add the Lambert Room in 1912.

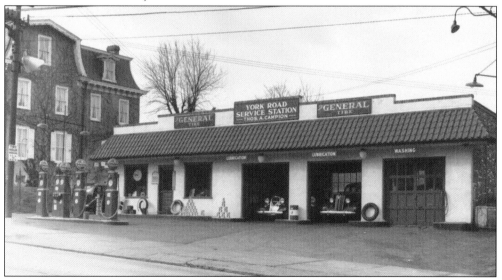

On the west side of Old York Road, directly opposite the library, was Thomas Campion's service station, now the site of the International House of Pancakes. Campion acquired the lease to this site in 1930 from Dr. Elwood T. Quinn, who built the Medical Arts Building on the next property to the north. The station was at this location until 1966.

Bids for the work to cut through Johnson Street from Cherry Street to Hillside Avenue were opened in August 1964. The street had long been divided by sections of privately owned backyards. The borough bought up the necessary land, razed old buildings, and made the street continuous from West to Hillside Avenues.

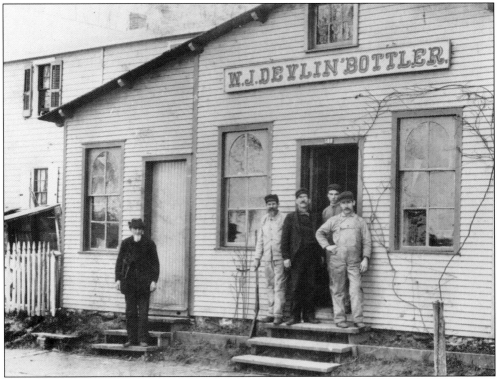

The W.J. Devlin Bottler building was located at 502 Hillside Avenue, with the Devlin home next-door at 504. A *Times Chronicle* advertisement of April 9, 1898, stated, "Carbonator and Bottler, Mineral Waters, Clausen's Lager Beer, Porter, Ale and Stout."

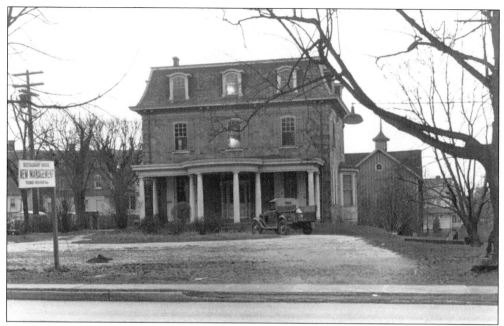

The Barley Sheaf Restaurant, located at the northwest corner of Hillside Avenue and Old York Road, was managed by Thomas Meehan at the time of this c. 1930s photograph. The house was on this site as early as 1877 and was probably razed when the Asplundh Tree Service bought the whole block facing Old York Road for its new headquarters in 1939.

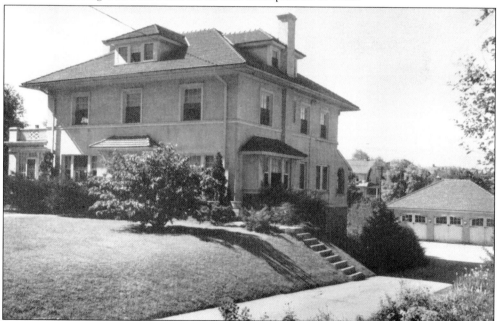

Meyer Bayuk, a cigar manufacturer, built his house at 505 Old York Road. His son, George, occupied it before Buell and Selena Miller bought it in 1931. In 1939 the building became the headquarters of the Asplundh Tree Service. The company added a two-story extension and remained there for 35 years. In 1976, the block became the site of Jenkintown Square, and a succession of restaurants occupied the house.

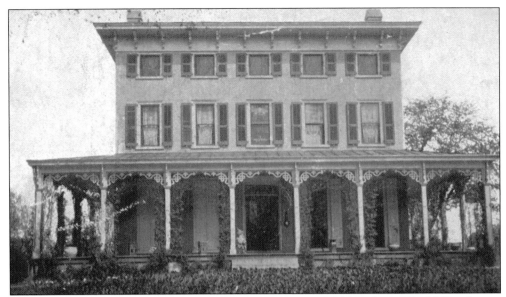

The site of Idylwilde, the estate on the southeast corner of Old York and Rydal Roads, was originally part of the Rachel Baeder estate and over the years had many owners. An early owner, Thomas Williams, purchased the house in 1876.

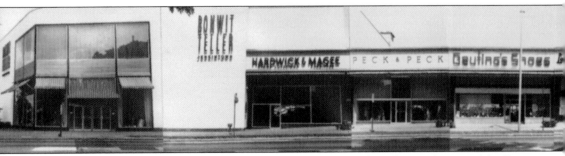

The Avenue of Shops was a series of small shops, anchored at the northern end by Bonwit Teller, which was built and opened in 1955. Along with the presence of the Strawbridge & Clothier and John Wanamaker stores nearby, the Avenue of Shops helped make Jenkintown a shopping mecca for the approximately 15 years it was in existence. On June 1, 1971, Federated Department Stores leased the site and announced that the first Bloomingdale's store in

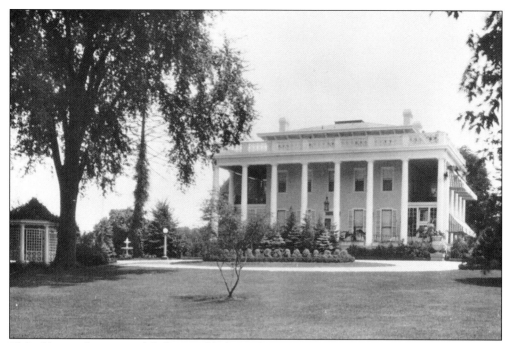

Idylwilde was later remodeled, most likely in the 1930s, in the Tara southern-mansion style evident here. The house was situated well back from the road and had extensive lawn and plantings in front. In 1955 the Schwehm estate, as Idylwilde was then known, was sold and cleared for the construction of the Avenue of Shops.

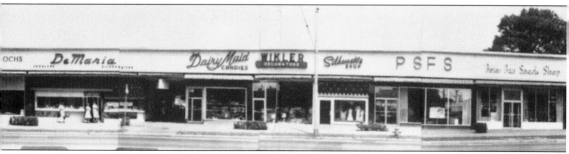

Pennsylvania would open within a year. A second story was added for the entire length of the structure, and the store occupied the whole complex. In August 1982, Bloomingdale's moved to the new Willow Grove Park Mall, and the building was sold to the Nutrisystems Corporation. Later, Zany Brainy occupied the corner store, and the remainder of the building was devoted to professional offices.

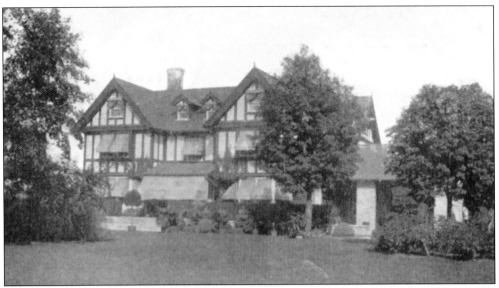

Wyndhurst, the residence of John Milton Colton, was in Abington Township when it was built in 1899. The house, designed by Horace Trumbauer, was an excellent example of the Elizabethan open-timbered style. There were extensive gardens and a greenhouse on the grounds that occupied almost the entire block facing Old York Road between Rydal Road and Rodman Avenue. The house was razed in 1930 for the construction of a suburban Strawbridge & Clothier store.

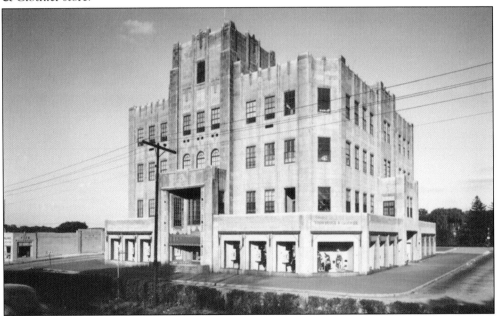

The Strawbridge & Clothier Jenkintown store was opened in 1931. After a court fight with Abington over Jenkintown Borough's annexation of the triangular piece of land the store occupied, it became part of Jenkintown. The store was bounded on the left, back, and right, respectively, by St. Francis Place, Colton Avenue, and Alexander Place. There were several small stores on St. Francis Place, including a Strawbridge & Clothier appliance store. In 1953 and 1954, the store added a vast new parking deck, which extended north to Rodman Avenue.

Two

Noble, Baederwood, and Abington

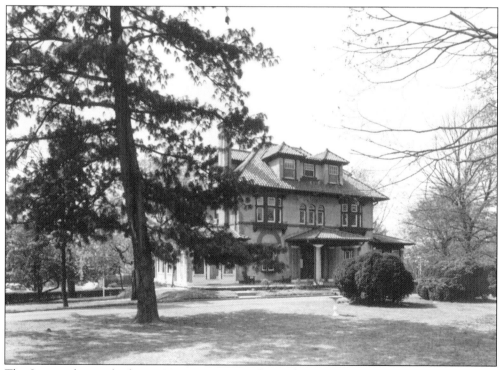

The Lupton house, built *c.* 1909 to 1916, was located on the northwest corner of Cloverly Avenue and Old York Road. It was later used as the office for Synnestvedt Realty until it was demolished *c.* 1955. The lot was used for Strawbridge & Clothier parking until it was sold and construction begun on Cloverly Plaza in 1992.

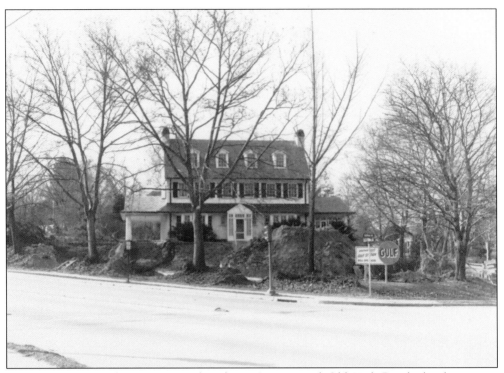

Located on the southwest corner of Rodman Avenue and Old York Road, this house was demolished in 1955; a Gulf station was built on the site. The station was razed in 1995 for the construction of a WaWa convenience store.

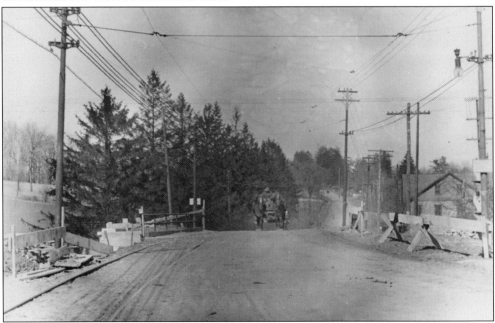

The Old York Road bridge at Noble station was rebuilt and widened in 1908 (as pictured) and again in 1931. Trolley tracks are visible on either side of the bridge. The far hillside on the left is part of the old Baeder estate, bought by John Wanamaker in 1901 and later sold for development.

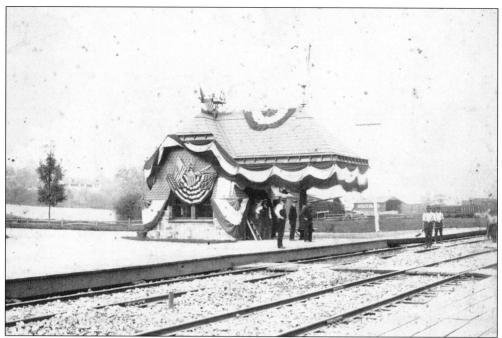

On September 4, 1889, the Noble station was decorated to receive President Harrison on his trip to Hartsville for the 150th anniversary celebration of the founding of Log College. The train line serving the station was a branch of the North Pennsylvania Railroad Company that ran from Jenkintown to Bound Brook, New Jersey, thence to New York. It had opened in May 1876.

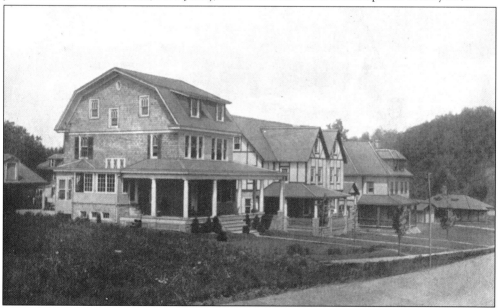

The community of Noble was largely developed from 1890 to 1910 on a portion of the Samuel Noble estate after his death in March 1886. The homes were advertised as "sylvan retreats from the crowded city, with the convenience of rapid transportation to both the city and nearby recreational areas." This view looks north on Upland Avenue toward the train tracks from a vantage point near Center Avenue.

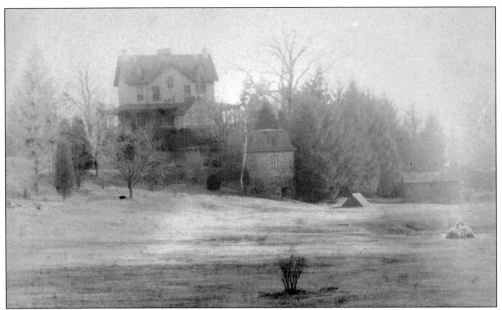

The Baeder mansion was built in the Centennial style by Charles Baeder, a very prosperous sandpaper and glue manufacturer. The estate covered some 250 acres and was roughly bounded by Hillside Avenue, Jenkintown Road, Highland Avenue, and Old York Road as far north as the current Harte Road. The whole parcel was sold to John Wanamaker in 1901. Upon Wanamaker's death, the acreage was divided into two portions for development: the Old York Hills area in Jenkintown and Baederwood in Abington. The mansion was demolished c. 1916–1920.

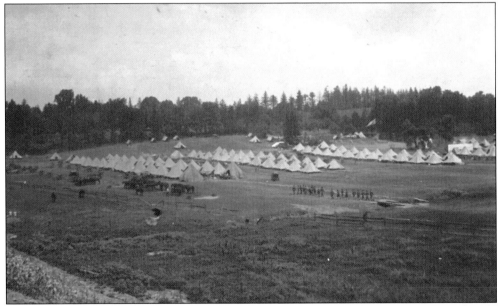

Located along the railroad tracks between Old York Road and Jenkintown Road on the old Baeder estate, Camp Wanamaker was volunteered by the owner, John Wanamaker, as a training ground for troops during World War I. It operated from July 15 to August 28, 1919, as an encampment of the Second Pennsylvania Field Artillery before the group moved to Georgia.

The Samuel Noble house was built soon after Noble acquired the property in 1839. The house was situated on the east side of Old York Road, just below the present-day World War II Memorial Island. Noble was a Quaker farmer and nurseryman who eventually owned about 100 acres in the area. The house was remodeled in the Italian Villa style shortly before this photograph was taken of the Noble family gathered on the porch and lawn.

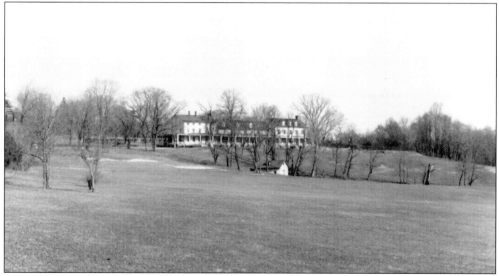

The Huntingdon Valley Country Club formed in 1896 and subsequently purchased part of the Noble estate for its first clubhouse and golf course. The clubhouse, designed by Horace Trumbauer, incorporated a portion of the Noble residence; the course extended down the valley through which the Fairway and Valley Road now pass. In 1928 the club moved to a new site in Upper Moreland Township and sold the property to the Baederwood Country Club, which operated the course until c. 1950. After a protracted zoning battle, the Van Sciver and Wanamaker stores were opened in 1957 and 1958; the Baederwood shops followed soon after.

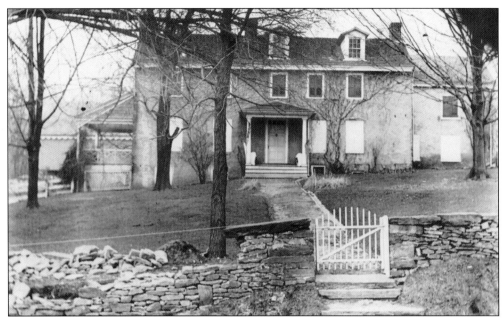

This house was long thought to be Springhead, which was built by John Barnes. However, a study of old deed records concluded that the house shown was the one that Stephen Jenkins built after Springhead burned, probably in 1717. A series of tanners worked on the property for more than 100 years. Several people owned the land before it was purchased in the 1920s by millionaire sportsman Major Nicholas Biddle. Biddle greatly modernized the house. It was located on the west side of Old York Road, across from the Noble residence, and was demolished sometime after 1956.

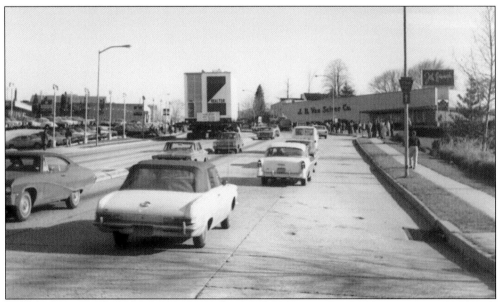

On March 30, 1968, the former Dager Real Estate building on the northwest corner of Old York and Baeder Roads was moved to the east side of Old York Road, about 500 feet to the north, and became the new home of Connor Real Estate. The building still stands and is located just below the World War II Memorial Island.

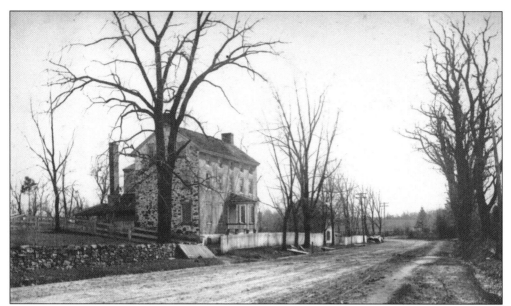

The Dillon house was the home of Jacob and Mary Dillon and stood on the east side of Old York Road, just north of Brook Road. The Dillon's daughter, Mrs. Ardemus Stewart, inherited the property *c.* 1845 and sold it some 45 years later to John Lambert. The house was demolished to make way for the Curtis residence.

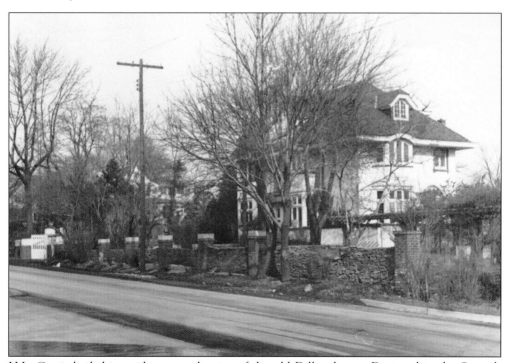

H.L. Curtis built his residence on the site of the old Dillon house. Designed in the Spanish style, the house was later purchased by Charles F. Penny, whose daughter, Pauline Holdsworth, was the last resident. The house was demolished in 1967 to make way for the TemPenns Medical Building.

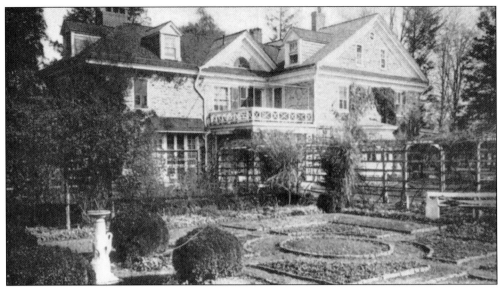

Currently located just south of the Abington Free Library and set back from Old York Road, Aysgarth was the home of John Lambert. The Abington Presbyterian Church received the property as a gift from one of Malachi Jones's descendants; the original house likely dates to the 1750s. The parsonage also served as a school for boys during the first half of the 19th century. The farm was sold by the church in 1856 and was eventually purchased by John Lambert.

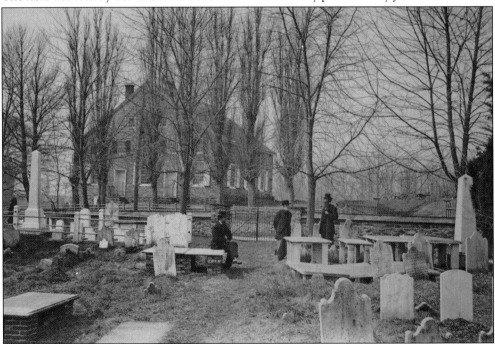

The Abington Presbyterian Church was founded in 1714 by Rev. Malachi Jones and 70 other people. The first church building was located on the east side of Old York Road in the center of the present-day cemetery. The second building was constructed in 1793 on the west side of Old York Road. In 1833 the building was expanded to the pictured dimensions. The cemetery in the foreground was established in 1719. The oldest remaining headstone dates to 1728.

48

In 1865 the church was rebuilt in the Romanesque style with a tall steeple that was a landmark for many miles around. With the sale of the church farm in 1856, funds were used to construct a new manse, shown to the right, in the Italianate style. The manse was demolished in 1962.

On October 6, 1895, a disastrous early morning fire swept through the church, consuming the entire structure within a few hours. Only the walls remained. The church was rebuilt using the surviving walls and was rededicated on September 25, 1896. Mrs. John Wanamaker donated a new bell, which still hangs in the steeple.

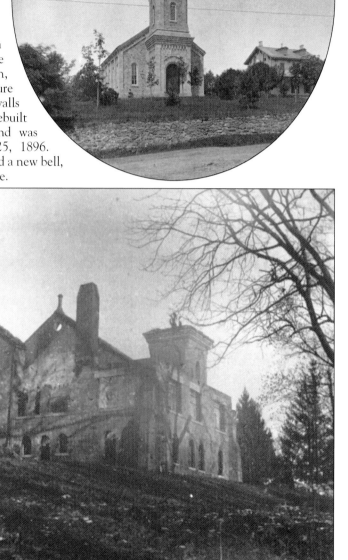

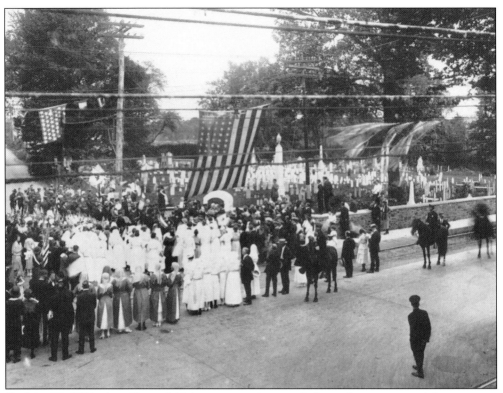

On May 28, 1921, the village of Abington turned out to dedicate the war memorial monument to those who served in the Great War. The monument still stands on the southeast corner of Old York and Susquehanna Roads.

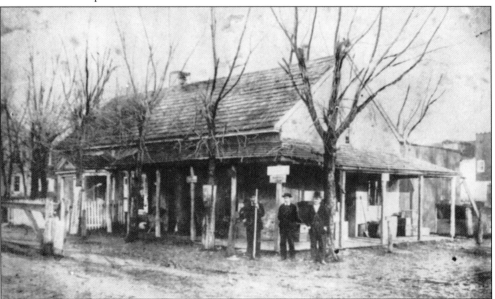

Located on the northeast corner of Old York and Susquehanna Roads, this old store and dwelling was built c. 1730 and stood until 1896, when Abington's third tollhouse was built on the site. Standing, from left to right, are Patrick Pendergast, Walter Boutcher, and Samuel McBride.

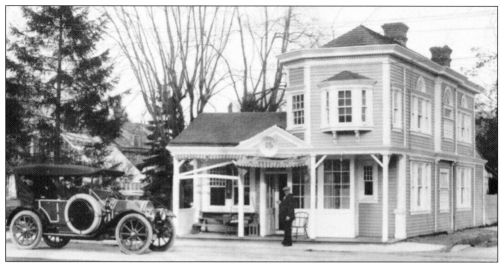

Abington's first tollhouse was built in 1804, when the Cheltenham and Willow Grove Turnpike was established. It was located on the west side of the road, extending into both Old York and Susquehanna Roads. Around 1872, the old building was replaced in the same location. The house stood in the path of the new trolley tracks, so it was demolished and replaced by a third building (shown) that was built in 1896 on the northeast corner of the intersection. Gatekeepers included Charles Dubree, Elihu Briton, William Weikel, Clem Weiker, and Andrew Hicks (the last and longest serving). Old York Road was freed from tolls in 1918, and the tollhouse was removed from this site and relocated on Susquehanna Road, across the street from Sewell Lane.

The new home of the Abington Bank & Trust Company was built on the site of the former tollhouse in 1928. By 1909 Dr. Oliver P. Rex owned half of the land surrounding the tollhouse fronting on Old York Road between Susquehanna Road and Guernsey Avenue and extending back to Abington School property. His home, the Palms, is the second house north of the corner. He died at sea on May 12, 1910.

Built in 1888, the first public school building in Abington Township is located on Susquehanna Road, east of Old York Road. It was used as both an elementary and a two-year high school. After the construction of a new high school immediately adjacent, this building served as an elementary school and, after 1939, as the school administration building. The building is still standing.

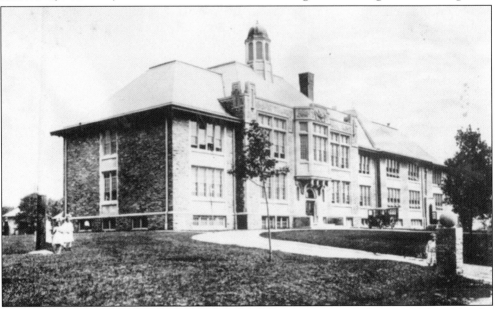

Construction of the new Abington High School began in 1908 and was completed by the opening of school in 1909. It served as the high school until 1956 and then as Huntingdon Junior High School until 1983. The building, located on the northwest corner of Huntingdon and Susquehanna Roads, was demolished in 1996.

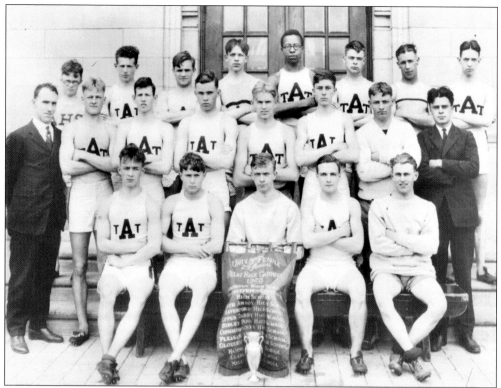

The Abington track team won the 29th annual University of Pennsylvania Relay Race Carnival in 1923. The winning team poses in front of the high school on Susquehanna Road.

The Abington High School Gymnasium was built in 1940–1941 and was a striking contrast to the existing buildings. The gymnasium, along with all but the first school building on the site, was razed in 1996 for construction of the Sunrise Assisted Living facility.

The blacksmith shop, owned at this time by David Winder, was located on the west side of Old York Road. The rear housed a wheelwright shop that fronted on Susquehanna Road. The building was constructed in 1807 by John Brugh, also a blacksmith. It was razed in the early part of 1900 and was eventually replaced by Powell's Drug Store. Winder moved to a new location farther north on Old York Road.

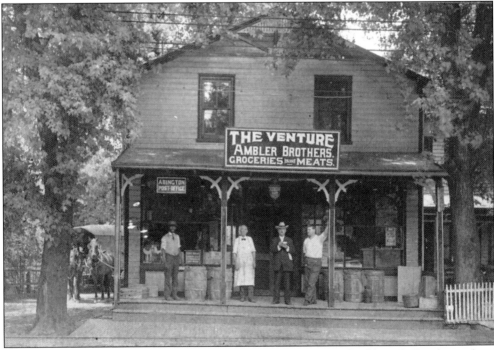

Several stores had existed at this location on the west side of Old York Road, north of Susquehanna Road, before the Ambler Brothers opened their Venture store in the 1890s. An 1898 advertisement guaranteed to give satisfaction to the purchasers of fresh and canned groceries, fresh meats, and also shoes and overshoes, at reasonable prices. The Abington Post Office was also housed here for a short time.

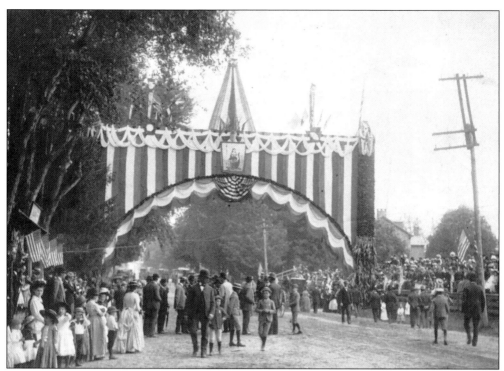

The Presidential Welcoming Arch was erected on Old York Road, just north of Susquehanna Road, for the 150th anniversary of the founding of Log College, the precursor of today's Princeton University. On September 5, 1889, Pres. Benjamin Harrison, Postmaster General Wanamaker, and Governor Beaver rode in procession from Wanamaker's home in Jenkintown to the original site of the college in Hartsville.

The presidential procession stopped in Abington at the great 60-foot-wide arch. Tickets were issued for seating in the grandstand, where President Harrison was received by many of the area's distinguished citizens. A group of children presented flowers to Mrs. Harrison and the other ladies of the entourage.

THE

RECEPTION

OF

THE PRESIDENT OF THE UNITED STATES,

ABINGTON VILLAGE, PENNSYLVANIA,

THURSDAY, SEPTEMBER 5TH, 1889.

The Honor of your Presence is requested

Thursday, September 5th, at 8.30, A. M

This Ticket admits One Person only to the Grand Stand on the Old York Road.

No one will be admitted to the Stand except on Presentation of this Ticket.

This Ticket Presented to Mr.

139 By

The Abington House was the home of Beauveau Borie, a Philadelphia banker and broker who built the house between 1897 and 1909. The building was located on a 5.5-acre property on the west side of Old York Road near the Eckard Avenue intersection. It was demolished c. 1927.

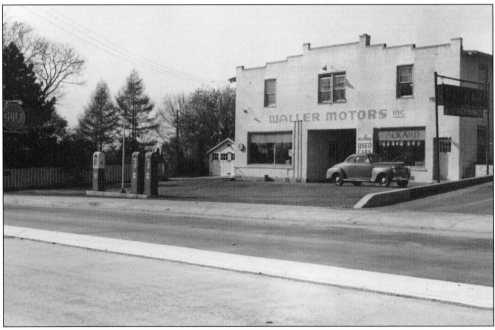

Located on the west side of Old York Road where the police station now stands, Waller Motors was established in 1933. In 1945, when the township purchased the site, it was described as the former Strouse & Jarrett automobile showroom and garage. Waller Motors moved to a new location at Old York and Harte Roads. The building was demolished in 1954 to make way for the new police station.

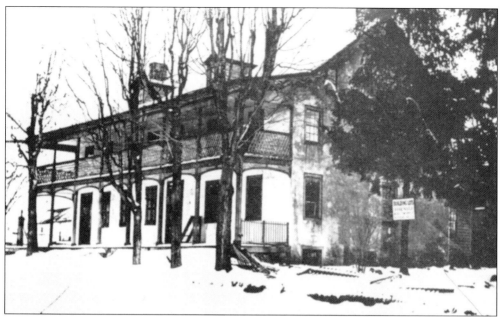

The Square and Compass Tavern was built in the early-to-mid-18th century and was the primary stagecoach stop in Abington. In 1787 Mary Moore purchased the license, and for a time Abington was known as Moorestown. Dr. Leighton Eckard, the eighth pastor of Abington Presbyterian Church and a strong advocate against drink, purchased the tavern in 1887 and had the building demolished. The ground was sold, and Eckard Avenue was built to open the area for development.

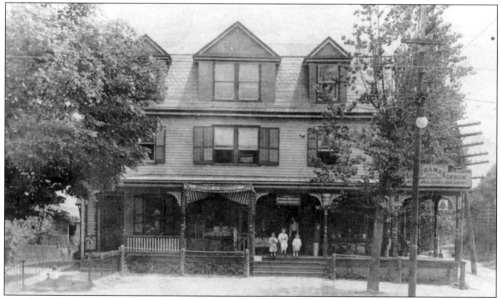

The Boutcher and Margerum General Store was built in 1900, and served as the voting place and a post office for Abington. The telephone operator for the area was located on the second floor, and the top floor was host to many community dances. The building served as the Parkhouse Store from 1935 to 1972. It still stands at the northeast corner of Eckard and Old York Road, currently housing the Abby Thrift Shop.

Looking south on Old York Road, from left to right, is the John Stevenson home, the first two buildings of Abington Memorial Hospital, and the township and police building from 1908 to 1926. The Stevenson home dated to colonial days and was located near the northwest corner of Horace Avenue and Old York Road. The property was purchased by the expanding hospital, and the house was demolished in the 1920s. The hospital opened in 1914; the nurses' residence at the left was built in 1916. The township administration building was completed in 1908 and housed all its departments until the move to larger quarters in 1926.

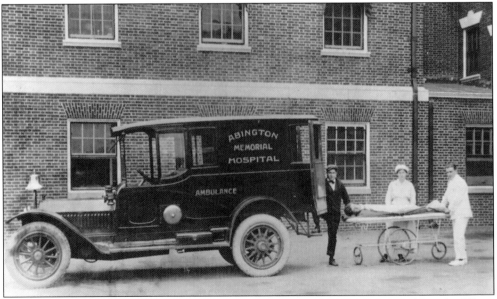

The Abington Memorial Hospital was founded in 1914 with strong support from the Elkins family. George Elkins, one of the few in the area to own an automobile, had often been asked to transport injured and sick patients to Einstein Hospital in Philadelphia and realized the need for a local hospital. The first hospital ambulance, purchased in 1914, was manufactured in Cleveland, Ohio, by the White Company.

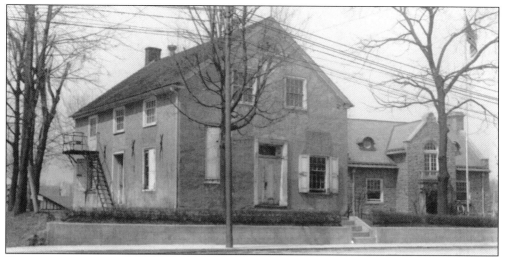

Known at various times as Mechanics Hall, Abington Hall, and Abolition Hall, this building was located between the hospital and the township offices and was built c. 1840. Over the years, the building was used as a meeting place, for dances, and briefly as a home for the Abington Lyceum. It was torn down in 1915 to allow for future hospital development.

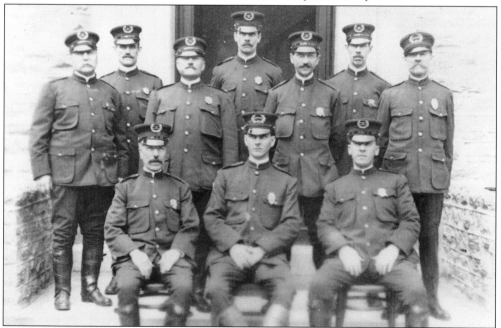

The Abington Police Department, with Chief Gordon S. Lever seated in the center, is pictured in 1910. The department was organized in 1906 because of Abington's incorporation as a first-class township that year. Before that time, a constable and a privately supported "Abington-Cheltenham Anti-Tramp Association" were responsible for controlling crime. From 1906 to 1908, the township offices, including police, were located in a house on the property of Samuel Jones on the east side of Old York Road, between Woodland Road and Horace Avenue. The first official township building, later known as Greystone Cottage, was occupied from 1908 until May 1926, when all offices moved to the new building on the southwest corner of Old York Road and Horace Avenue.

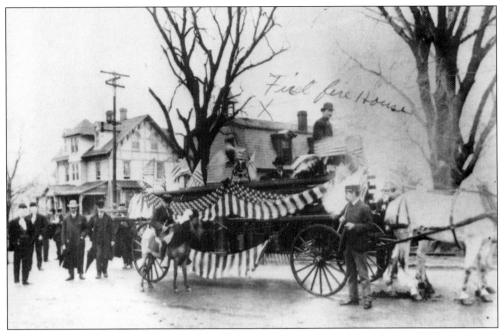

Behind the decorated fire wagon are the Samuel Jones house and the second firehouse of the Abington Fire Company, both located on the east side of Old York Road between Woodland Road and Horace Avenue. The Abington Fire Company was founded in 1889 and was originally located in a building on Old York Road below Horace Avenue. In 1893, the company moved into this new firehouse and remained here until 1912 when they swapped land with Edwin Stapler on the south side of Horace Avenue and built a new firehouse. The second firehouse building was moved back onto Bockius Avenue where it still stands.

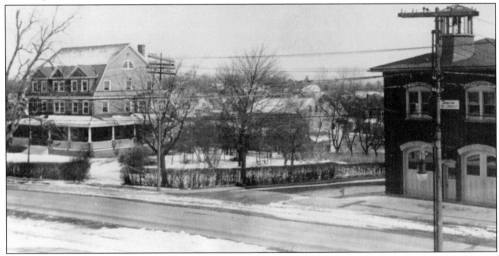

In 1897 Edwin Stapler opened his new home, Stapleton, as a summer boardinghouse. Stapler was a prominent farmer and landowner in the area. He opened Horace Avenue and named it after his brother. The house was later converted to apartments and was finally razed to make way for the hospital's Levy Building. To the south is the third home of the Abington Fire Company. The company was located in this building until 1950, when a new firehouse was built on Horace Avenue behind the township building.

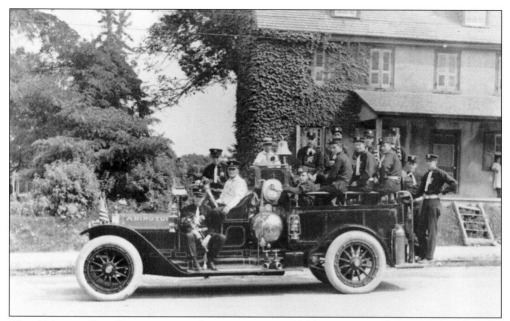

The Abington Fire Company turned out on its new 1914 pumper truck. Pictured in front of the Bockius-owned house at the northeast corner of Old York Road and Woodland Avenue are the following, from left to right: J. Allen Boutcher, Howard Nice, Chief William Ferguson (at the wheel), John Ferguson, Albert Boutcher, Paul Pubanz, Norman Boutcher, Rich Insell, John Roatch, Harry Saylor, Joe Brogan, Willie Brogan, Walter Brogan, and John Boutcher.

The Samuel Bockius Sr. house, located on the northeast corner of Woodland Avenue, dated to colonial times and was owned for generations by the Bockius family. The house was demolished between 1916 and 1927; an Inn Flight Restaurant currently occupies the site. To the right is another Bockius home, which later became the Bernie Woodland Inn, located on the southeast corner of Woodland and Old York Roads. This house was razed in the 1920s for commercial development. The Abington Hospital Levy Building is now located on the site.

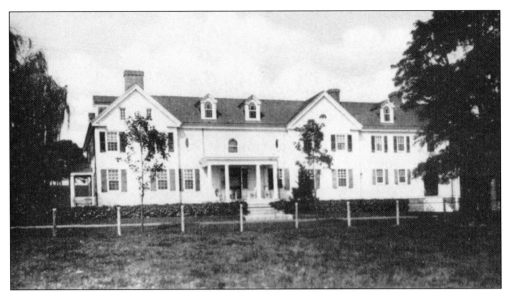

In February 1909, George Elkins purchased the S.J. Stevenson estate, located between Brentwood, Old York, Edge Hill, Welsh, and Huntingdon Roads. It received the name Folly Farms from Elkins's daughter's opinion of the project. The land was sold to William G. Davidson in February 1920 and was renamed Brentwood Farms. In 1952 the farm was sold for development, but the main house remains and is used as the rectory for Our Lady Help of Christians Roman Catholic Church.

In this view looking north on Old York Road near Brentwood Avenue toward Edge Hill Road, Brentwood Farms occupies the ground on the east side of the street. To the west is the lawn of the Highland House with a few of the newer homes visible through the trees. The porch to the right is attached to the Old Forge Inn, which was the former home of David Winder Sr. and was later demolished in the 1950s.

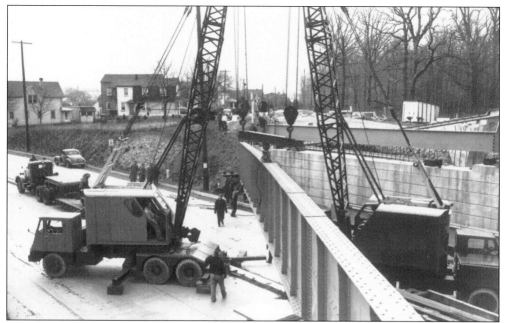

Old York and Edge Hill Roads originally intersected at the Old York Road level. In 1947 a major construction project was launched to create an overpass. This picture, taken on March 27 that year, shows a support being lifted into place. The homes on the north side of Edge Hill Road are visible. The apartments located on the south side have yet to be built.

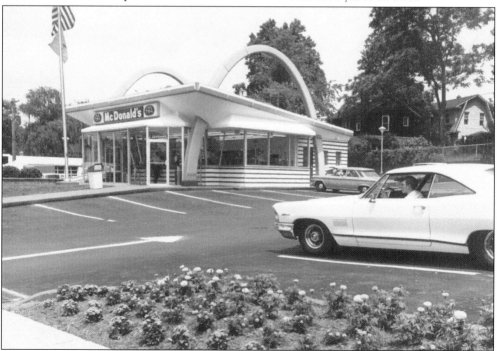

McDonald's was founded by Ray Kroc in 1955. In 1966 the Abington location was opened in the 1600 block of Old York Road. The building design was in the original style of all the McDonald's restaurants; the original has been rebuilt and modernized several times.

Located at the southwest corner of Old York and Welsh Roads, the residence of H. Meier was built between 1909 and 1916. It later became the home of Dr. C.F. Cornelius, who called it Altamonte. The property, still at the site in 1937, was later demolished. The first Hot Shoppes Jr. drive-in restaurant in the Philadelphia area opened here in the 1950s. A Roy Rogers restaurant later occupied the site, which is now a Boston Market restaurant.

The Roychester Park Community House in Overlook Hills was originally a barn on farmland owned by W.W. Frazier. The Roychester area received its name from the names of the two sons of the farmer; development of the land was started by Henry Speck in 1917. A later builder purchased the Frazier property, began the Overlook Hills community, and donated the barn and 5 acres to the township for use as Roychester Park in 1941.

Three

WELDON, GLENSIDE, NORTH HILLS, AND ARDSLEY

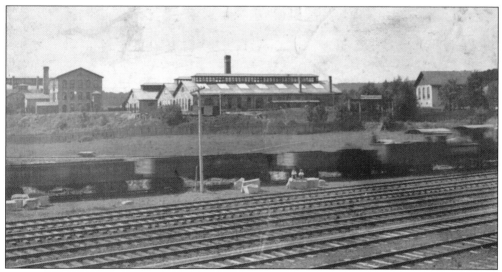

In 1884 the Wharton Railroad Switch Company opened its new plant to manufacture patent switches, crossings, frogs, and Wooten locomotives. The company was located northwest of Jenkintown along the tracks. It went out of business in 1918, and the land and buildings were purchased by Standard Pressed Steel in 1919. The cupola stack in the foundry building was from the Confederate iron-clad *Merrimac* and was bought from a junk dealer in Philadelphia.

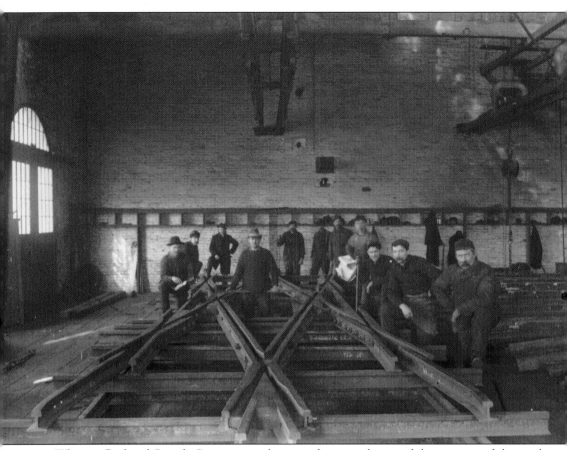

Wharton Railroad Switch Company workers are shown with one of the sections of the track that the company manufactured from 1884 to 1918. Many of the workers were from the Irish immigrant families that had settled in the area after the Civil War. Some of them settled in Jenkintown in the area known as "Seventeen Acres," bounded by West and Hillside Avenues and Leedom and Maple Streets. Others occupied small houses built along the railroad tracks northwest of the borough on and near the land owned by Edward Mather. This area became known as Corktown as a result. In 1874 the North Pennsylvania Railroad Company purchased a large piece of the Mather property. In 1882 the Wharton Railroad Switch Company bought 40 acres of that land from the railroad and built its new plant, which opened in 1884. As the company grew in importance, the original name of Corktown gave way to the new name of Switchville.

This view of the Switchville Crossing looks from roughly Baeder Road east along Jenkintown Road toward Jenkintown prior to the building of the bridge. The white house at the far end of the road is at the southwest corner of Walnut Street and Runnymede Avenue.

The Raymond Roberts house is located on the south side of Jenkintown Road, just west of Abington Avenue. Built in 1894, the house is still standing. This photograph dates from 1920.

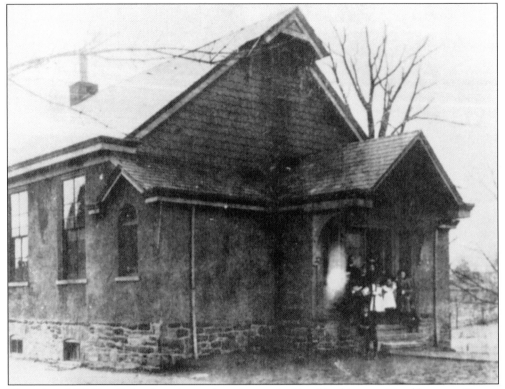

The original Weldon School was located on the south side of Jenkintown Road between Easton Road and Abington Avenue. This photograph shows the school, c. 1895. As the area grew, a larger building was constructed on Easton Road and occupied in 1908. This original structure, after much renovation, was converted into a twin home and is still on the site.

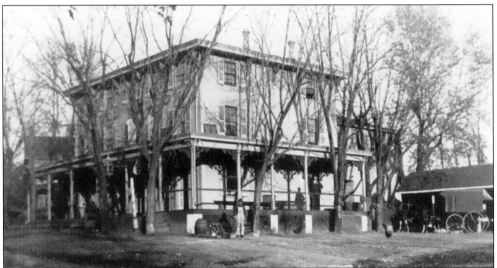

The Hotel Weldon was conveniently located right across Jenkintown Road from the tollgate on the Germantown and Willow Grove Turnpike. The hotel was built in 1855 by David Lukens and was rebuilt after a disastrous fire in 1901. It was sold to the Conti family in 1919 and became the Casa Conti restaurant. The property is now home to the New Life Presbyterian Church.

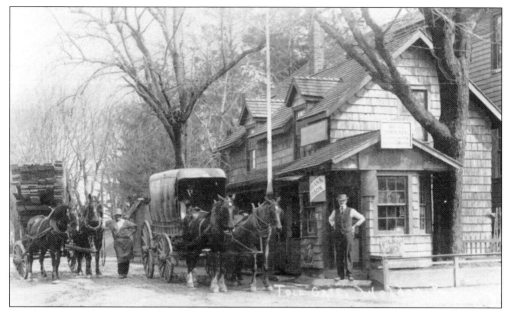

The Weldon tollhouse stood on the northeast corner of Easton Road (the Germantown and Willow Grove Turnpike) and Jenkintown Road. The turnpike was laid out *c.* 1717 and ran from Mount Airy, Philadelphia, to Willow Grove. On Sundays, those using the roadway to get to church were exempt from tolls. The Harmer blacksmith shop was behind the tollhouse. The corner is currently the property of Sloane Toyota.

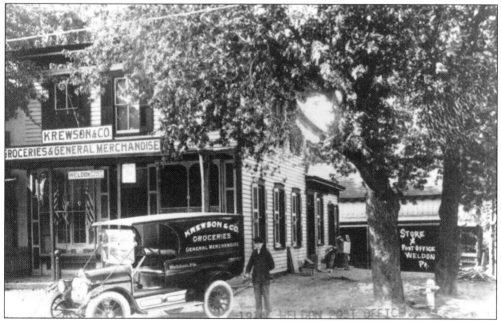

In 1914 Krewson & Company Groceries and General Merchandise was the local general store and post office. The building was located at the southwest corner of Easton and Jenkintown Roads, directly across the street from the Weldon Hotel. This site is now the home of Madonna's Distributing Company.

The original Weldon Fire House of 1911 had two garages and stood on land donated by W.T.B. Roberts (also the site of the present firehouse). The Weldon Fire Company No. 1 was organized in April 1904 and was the second company in the greater Glenside area. The first piece of equipment was a horse-drawn hose reel that was housed in a building just north of the one shown here. The fire call was an iron ring that was struck by a sledgehammer.

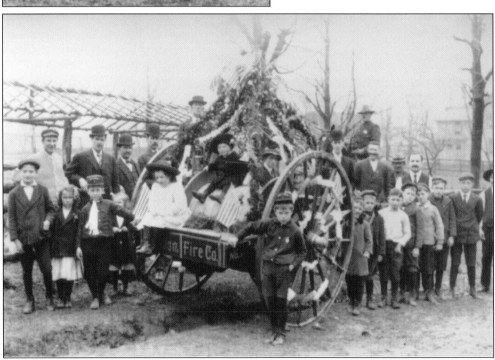

This undated photograph shows the Weldon Fire Company's festively decorated hose reel with members of the company and their children.

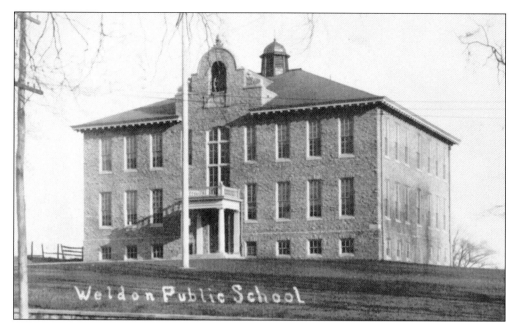

Construction began in 1906 for a new Weldon School, which opened its doors in 1908. With its opening, several smaller schools in the area were closed. The building still provides classes for the area's elementary-aged children, but will be replaced by the Copper Beech Elementary School currently under construction.

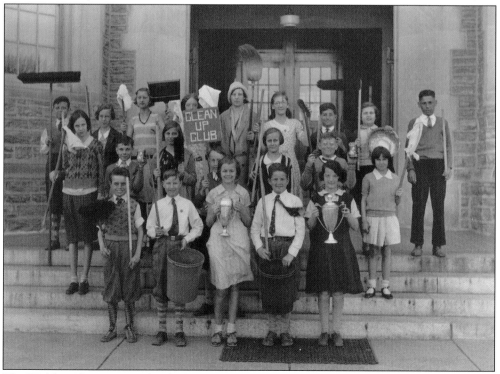

The Weldon Elementary School Clean-up Club, photographed in the early 1930s on the front steps of the school building, was just one group of champions that the school produced.

The pleasure of your presence
is requested at the opening of the

-: *Keswick Theatre* :-

Easton Road, Wharton Avenue and Keswick Ave.
GREATER GLENSIDE

Thursday Evening, December 27, 1928

EDWIN N. JOHNSON

Doors open · 7.15 P. M. · · Show begins · 8.15 P. M

ADMIT ONE

The Keswick Theatre, designed by Horace Trumbauer and built by Edwin N. Johnson, opened with much fanfare on Christmas Day 1928 with a performance of the Glenside Kiwanis Follies. The theater's first film, *Glorious Betsy*, was shown December 27. In February 1929, the beacon on top of the theater began operating. It was the most powerful beacon on the East Coast and could be seen for 70 miles. After many years as a vaudeville and movie theater, the building was threatened with demolition several times in the 1980s, but is once again a successful enterprise staging live performances.

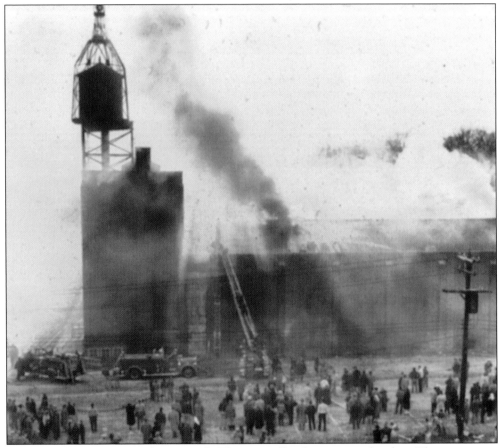

On December 17, 1952, the Keswick Theater suffered a spectacular fire. There were an estimated 200 children in the auditorium at the time the fire was discovered, but an orderly evacuation ensured that no one was hurt. Although the fire was confined mainly to the roof and air conditioning system, there was heavy smoke and water damage. The theater remained closed until July 1954 while undergoing a complete renovation.

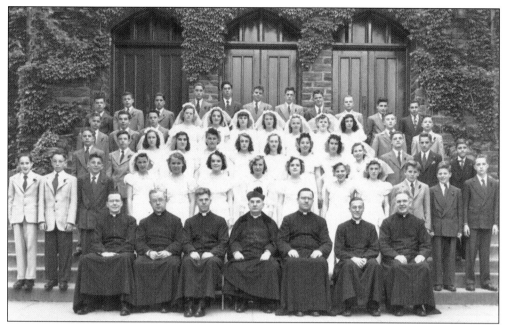

The 1948 graduating class of St. Luke the Evangelist is shown on the steps of the old church on the west side of Easton Road, just south of Fairhill Avenue. Seated, from left to right, are Fr. Frederic Hickey, Fr. Francis Carr, Fr. Otis J. Patterson, Msgr. Charles Mynaugh, Fr. Michael B. McShane, Fr. Eugene Lanshe, and Fr. Joseph Feeney. St. Luke's was organized in 1905; ground was broken for the church in June 1909. The building was razed in 1969, and a modern-style church was erected on the site.

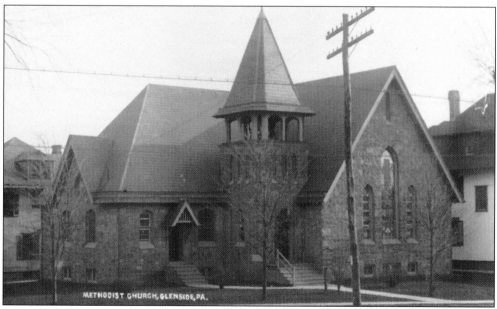

Located at the corner of Easton and Fairhill Roads on a lot donated by W.T.B. Roberts, the Glenside United Methodist Church was built and occupied in 1899. The church was enlarged several times before a new building was constructed at the corner of Menlo Avenue and Easton Road in 1955 to replace the old sanctuary.

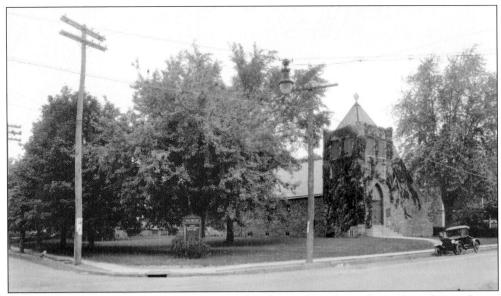

The original building for St. Paul's Evangelical Lutheran Church was located on the northwest corner of Easton Road and Mt. Carmel Avenue. The congregation was established in 1902, and the church was built between 1903 and 1904. In 1929 the façade shown here was completely altered to accommodate to the newly lowered street level that resulted from the construction of the new railroad bridge. The old church was eventually razed and replaced by a new building in 1952.

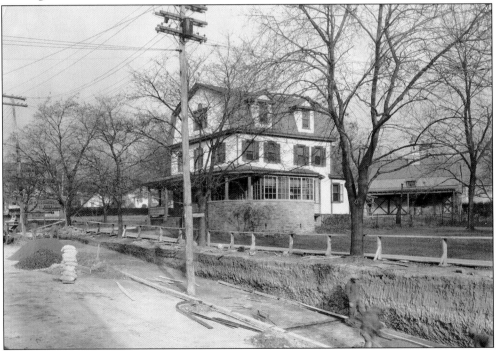

The home of Dr. William H. Huber is shown in November 1928 while the sidewalk is being lowered at the northeast corner of Roberts and Mt. Carmel Avenues. This house was demolished in 1964 to create a large parking area behind St. Paul's Lutheran Church.

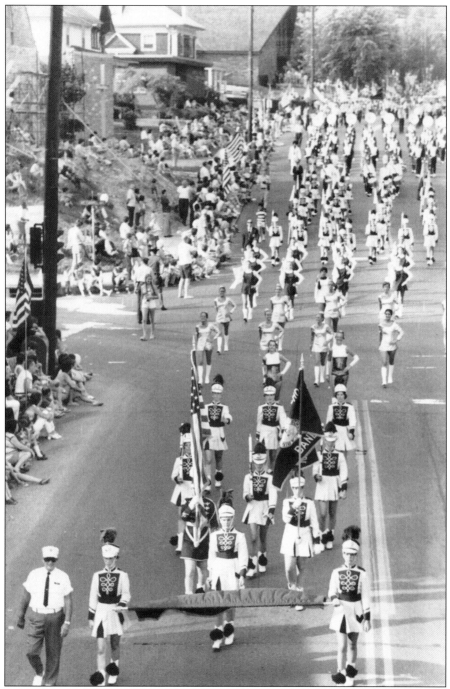

The Glenside Fourth of July parade has marched annually since 1904. Organized and run by the Glenside Patriotic Association, it first began as a firemen's parade. The parade starts at the North Hills Veterans of Foreign Wars Post in Abington Township, proceeds down Easton Road, and ends in Cheltenham Township at Renninger Park. In this 1970s photograph, the Abington High School marching band parades through the intersection of Mt. Carmel Avenue and Easton Road.

The swimming pond was a popular local attraction in the 1800s and just beyond the turn of the century. Many of the old-time locals still mention "the Pond" that was used by swimmers during hot summer months. It was located around the intersection of Sylvania and Geneva Avenues. This picture was taken between 1900 and 1910, prior to its draining for the construction of homes by W.T.B. Roberts.

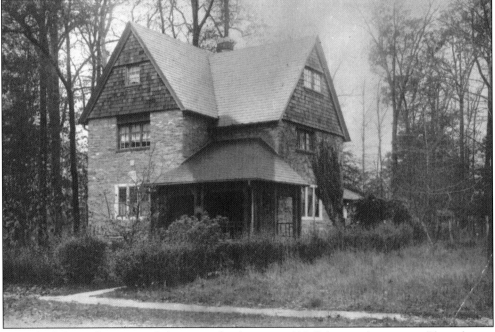

Typical of the architecture of the time, this house at 412 Sylvania Avenue in Glenside was built in 1904. The building exemplifies the style and detail associated with the developments of the period. Some of the features include a varying stone exterior, inside and outside sculptured wood supports, and stained-glass windows.

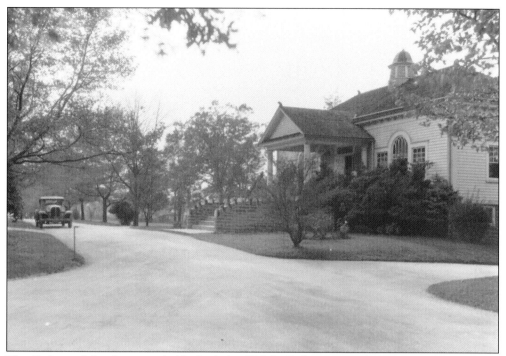

The Roberts School was probably built by W.T.B. Roberts to make good on his claim of excellent educational facilities in the immediate area. First occupied by students in his Glenside Highlands development, the school was closed with the opening of the new Weldon school in 1908. From 1915 to 1926, the building was home to the Rosemore Club, famous for its local ball team and community activities. The structure was originally located on Rosemore Avenue between Roberts Avenue and Easton Roads. It was relocated to Ardsley Cemetery for use as a mortuary chapel.

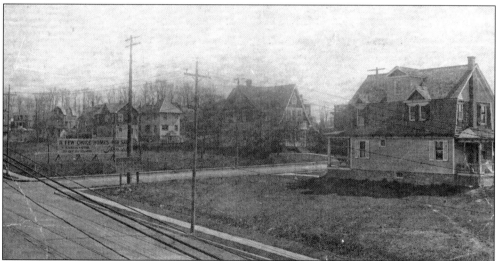

William T.B. Roberts was largely responsible for the residential development of Glenside. He planned the growth of his new communities by laying out water, sewer, electric and gas lines, sidewalks, and trees, before ever breaking ground for his first house. He built both grand and modest residences, such as these along Keswick Avenue and the adjoining streets.

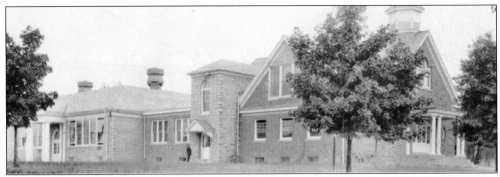

The North Hills School was called the Remlu School when it opened in 1896. It is located at Central and Pine Avenues, north of Limekiln Pike. The area was being developed by a man named Ulmer, who called it by his name spelled backwards. From 1908 to 1914, the school was known as Edge Hill School, then called North Glenside until *c.* 1928–1929, when it received its current name.

Skeath's Pharmacy is still located at 2732 Limekiln Pike, although it is no longer owned by the Skeath family. Alex H.B. Skeath first opened the drugstore in April 1921 and sold it just before his death in August 1960. For many years, it was the only drugstore for miles around.

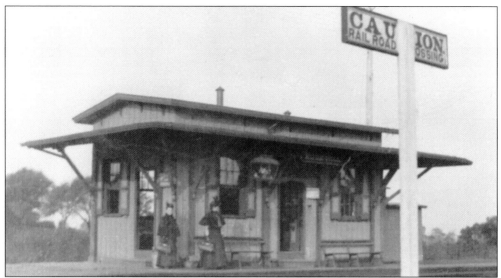

The Edge Hill train stop was established in 1855; the first frame building was erected in 1873. The name was changed to North Glenside in November 1923; it became the North Hills station in 1931. A new building replaced the old one when the bridge over North Hills Avenue was built.

The Edge Hill Fire Company No. 1 was formed in 1908. The first firehouse was built in 1910 and was located at Mt. Carmel Avenue and Limekiln Pike on land owned by the Reading Railroad. The Abington-Cheltenham boundary line ran through the building. In 1933 a large firehouse was built in Abington Township at Limekiln Pike and Cricket Avenue.

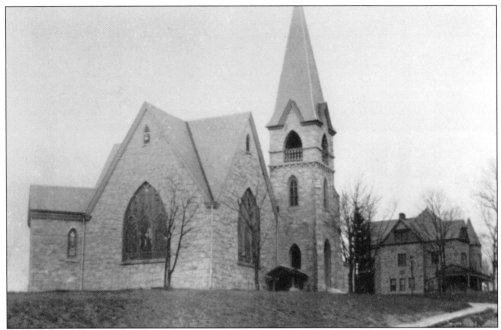

The Carmel Presbyterian Church, originally known as Edge Hill Presbyterian Church, was organized in 1872, and services were held in temporary locations. A chapel was built in 1876 at the northwest corner of Mt. Carmel Avenue and Edge Hill Road. In 1894 the congregation began construction on a larger sanctuary that was dedicated in 1896. This photograph, taken around March 1898, shows the church sitting high on top of the hill at the far end of the Village of Edge Hill. The building just beyond the church is the manse.

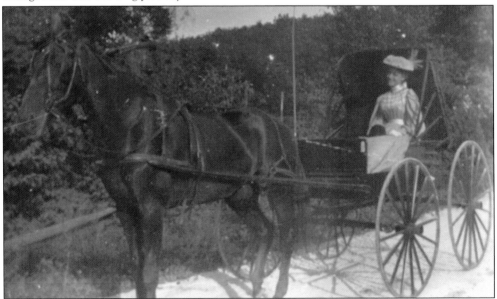

This young woman takes a carriage ride in Tyson in September 1897. Tyson, originally known as Tyson's Gap during colonial times, was the area surrounding Ardsley station along Jenkintown and Edge Hill Roads. Mainly farmland and fields, much of the land was owned by the Tyson and Hamel families.

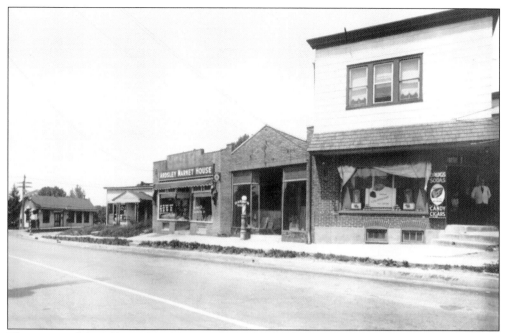

The center of the village of Ardsley was along Jenkintown Road where Edge Hill Road and the train crossed. The market, the barbershop, and the drugstore were all located on the north side of Jenkintown Road, east of the Ardsley station. The buildings, though altered, still remain.

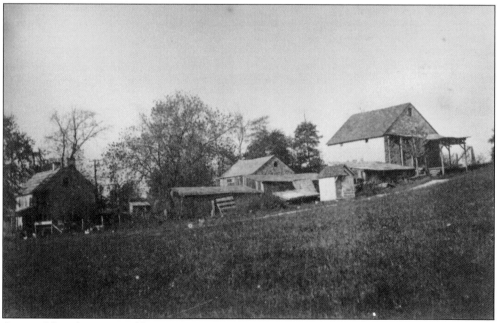

George Hamel came to Abington in 1837. He was a farmer who also mined the deposits of silica on his land that were necessary to the production of steel. His marriage to Hannah Tyson brought him large Tyson holdings. The Hamel house and farm buildings were located on Jenkintown Road near Tyson Avenue. The two stone barns remain; since 1936 they have served as the home of the North Penn Veterans of Foreign Wars Post No. 676.

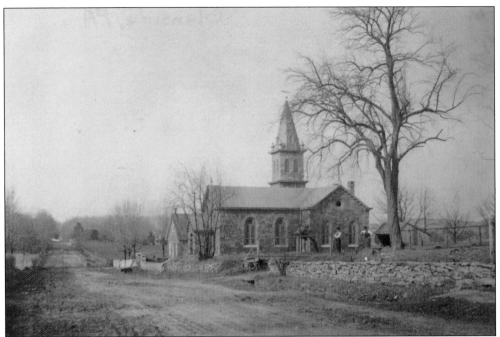

The Romanesque Revival St. Peter's Chapel was designed by Russell Smith in 1881. It was located on Easton Road at the corner of the Smith property. Originally wooden, the church was faced in stone in 1884. In 1956 the building was demolished to make way for the current structure. Just beyond the church stands the Weldon Ladies Soldiers' Aid building, home of the organization that supported Civil War soldiers and their families during and after the war.

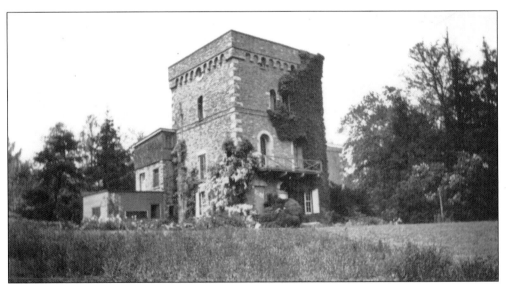

Edgehill was the home of the famous 19th-century scenic and landscape painter Russell Smith. The castlelike structure was built in 1854–1855, affording views of the countryside. It was home to three generations of the Smith family. Other family members were also well-known artists: Russell's wife, Mary; their son, Xanthus; and their daughter, Mary Russell Smith. The house still stands, and the surrounding land was developed in the 1950s.

Four

ROSLYN, CRESTMONT, AND WILLOW GROVE PARK

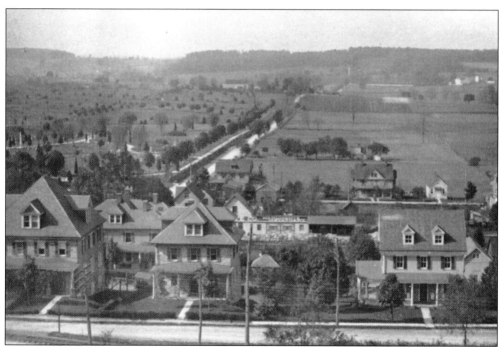

This pre-1925 view looks west on Susquehanna Road across Easton Road, just north of the intersection of the two. At the left behind the houses is Hillside Cemetery. The Hillside Marble & Granite Works Company sign can also be seen behind the houses. It was located between Easton and Bradfield Roads on the north side of Susquehanna Road, which was then a narrow two-lane road. The first and second houses from left to right are still standing. The third was demolished in April 2000.

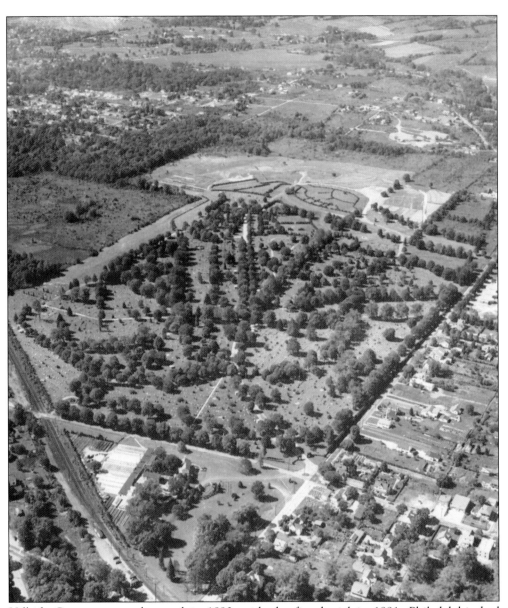

Hillside Cemetery was chartered in 1890, with the first burial in 1891. Philadelphia had recently banned new cemeteries within the city limits, so Hillside attracted both local and non-local burials, including some German veterans of the Franco-Prussian War. A funeral trolley operated from 1912 until 1930, delivering the caskets to Tyson Avenue and Bradfield Road, where they were met by the cemetery hearse. In 1953 the Hillside Cemetery bought Ardsley Burial Park, which had been founded in 1906 by W.T.B. Roberts, thus becoming the only cemetery in the country to be served by two rail stations, Ardsley and Roslyn. The cemetery was privately operated until 1994, when it was purchased by Stewart Enterprises.

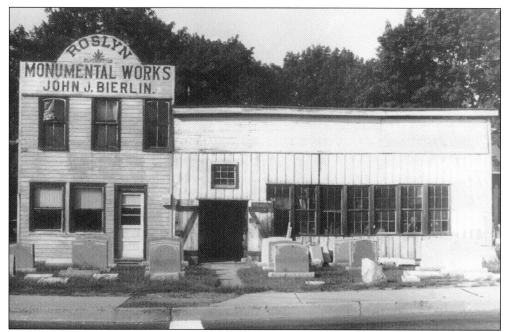

Roslyn Monumental Works, owned by John J. Bierlin, was located at Susquehanna and Bradfield Roads from as early as 1913. The presence of two large cemeteries in the immediate area created a great demand for headstones. The company went out of business, and the lot was cleared for town homes in 1975. The Bierlin family also owned two greenhouses in the area.

The first school in Roslyn was begun in the left side of this house, built by John Tyson c. 1822 and pictured here after it became a private home. Known as the Valley School, it was abandoned in 1858 when the new Plank Road school was built at the northeast corner of Easton and Edge Hill Roads. The building still stands, set back from the north side of Susquehanna Road and west of Bradfield Road.

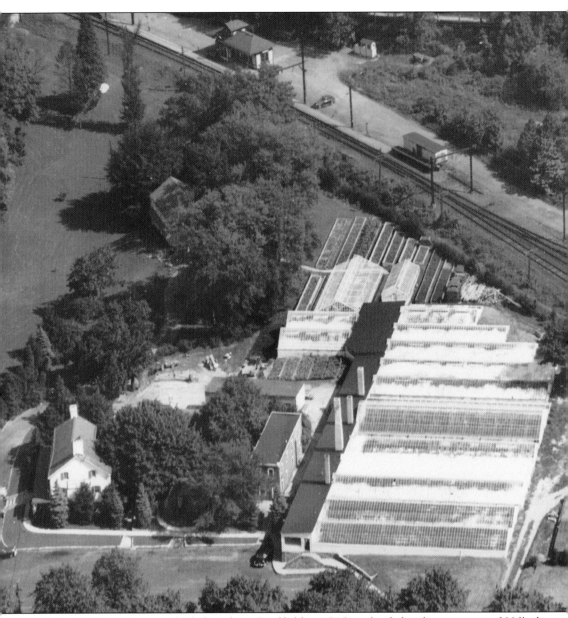

Bradfield Mansion was built by Abner Bradfield *c.* 1795 on land that became part of Hillside Cemetery. The building later served as the cemetery office, before it was razed in 1996 to clear space for a Genuardi's Supermarket. The greenhouses were among many that provided roses and other flowers for a number of years. Roslyn was a major center of the commercial rose-growing industry from 1895 through the first half of the 20th century, although the number of greenhouses gradually declined. The name Roslyn was chosen for the area's new post office in 1895, in recognition of the fine roses produced in the local greenhouses.

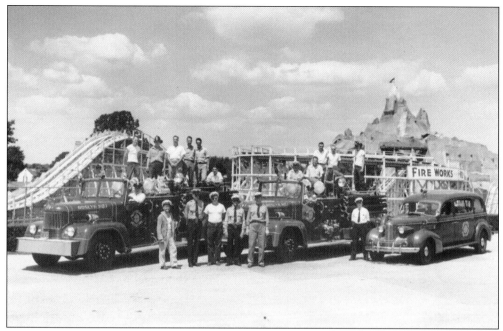

Roslyn Fire Company No. 1 was formed in 1922. In April 1923, it received its charter and started work on a firehouse, which was first used in December of that year. In August 1922, the company purchased a Brockway fire truck from the Philadelphia Navy Yard. In November 1923, they renovated a Paige touring car into a chemical truck. The company shows off two Hahn pumpers and the 1939 LaSalle ambulance at Willow Grove Park in 1954.

This view looks north on Easton Road through the Crestmont section toward Willow Grove Park and dates from June 1935. This area of the township was originally called Rubicam by the railroad company, but W.T.B. Roberts thought the name Crestmont was more attractive to potential buyers and persuaded the railroad to change the name.

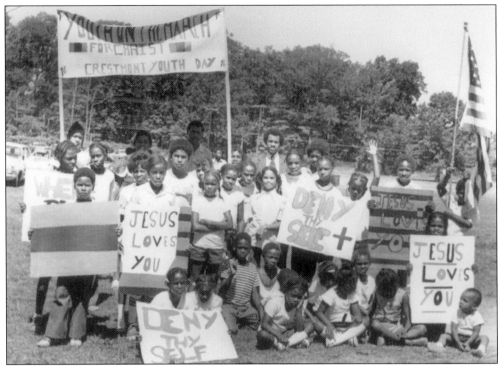

In 1976 this Youth for Christ rally was held at Crestmont Park. The park was purchased by the township in 1935, from land that had once been part of the Willow Grove Park. In 1975 a swimming pool was opened.

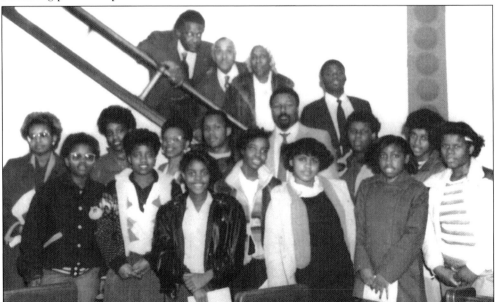

Pictured in the rear center with the youth group of the Willow Grove chapter of the NAACP is Mrs. Helen Lee Johnson, the first black teacher in Abington Township. Johnson was educated in the township schools and returned from college in 1930 to begin a 38-year teaching career in Abington that started at the Park School.

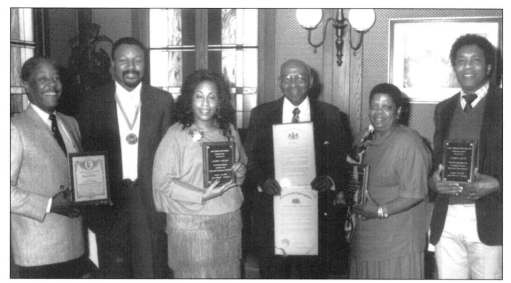

The Willow Grove chapter of the NAACP's Freedom Fund Banquet recognized Norman Fenell, Allen Mitchell, Sondra Wilson, Dr. Alonzo Sudler, Esther Pender, and Sam Rines. In 1955 Dr. Sudler became the first black director of the pharmacy at Abington Hospital, a post he held for many years. He began work at Woolfolk's Drug Store in Crestmont before joining the hospital's pharmacy staff in 1953. Woolfolk's Drug Store was opened on May 11, 1929, by Harold Woolfolk at the corner of Prospect and Rubicam Avenues. In 1951 the drugstore moved to Hamilton and Easton Roads.

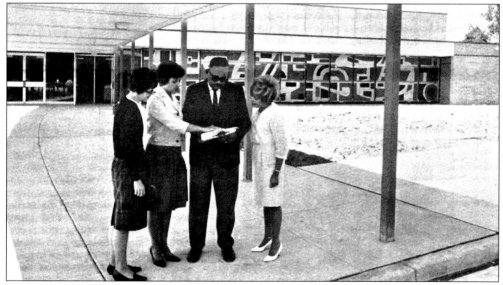

The Willow Hill School, located at Coolidge Avenue and Old Welsh Road, opened in 1965. It replaced the Park School, the original building of which dated from 1901. Morton M. Brooks served as the first principal of the Willow Hill School when it opened. Brooks began as a teacher in 1949 at the Park School and became principal of the Park-Hamilton Schools in 1960. He was the first black elementary school principal in the district and is pictured here conferring with teachers Mrs. B. Hillsley, Mrs. P. Gump, and Mrs. S. Solomon.

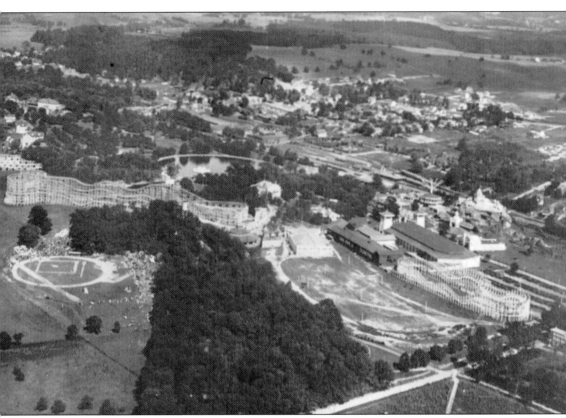

Willow Grove Park was located 12 miles from the center of Philadelphia on 130 acres of rolling meadow in Abington Township, across Moreland Road from the resort hotels in the village of Willow Grove (located in Upper Moreland Township). The park was established in 1896 by the traction company as a means to get people to use the trolley line connecting Philadelphia to Willow Grove that had been completed in 1895. The park opened on May 30, 1896, and stood for many years as one of the great amusement parks in America. More than 1 million people visited the park during the first summer. Until 1926, when the traction company leased the park, no admission fee was charged; money was made on trolley fares and the concessions. Its remarkable achievement was due to combining the best in musical entertainment and amusements, a lush setting, and exceptional service. Everything was done to assure that visitors would leave with smiling faces and happy memories. This aerial photograph of the park was taken in 1924.

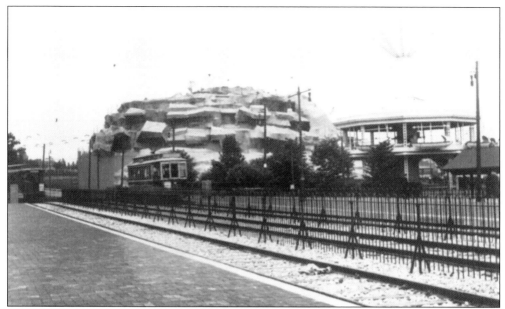

Trolleys to Willow Grove Park came up Old York Road and over Welsh Road to the train line, which they followed to Berrell Avenue and then out to the station on Davisville Road, where they deposited their passengers on the east side of the road. This 1905 view looks across Easton Road toward the park from the trolley platform. The Mountain Scenic and Flying Machine rides are clearly visible.

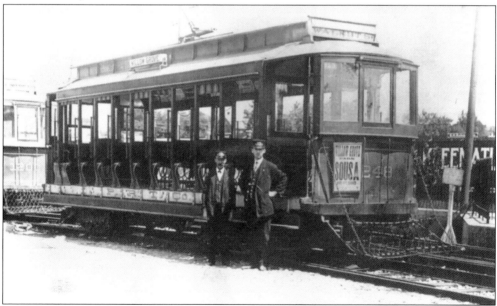

The Philadelphia Rapid Transit Company, owned by P.A.B. Widener and George Elkins, commissioned 100 electric trolley cars to carry picnickers, music lovers, and thrill seekers to and from the park. The advertisement on the front of this trolley car trumpets John Philip Sousa's band. Sousa, known best as America's March King, appeared at the park in 1901 for the first time and made appearances virtually every year until the concerts ended in 1925. Sousa's last concert drew more than 100,000 people.

One of the most famous rides in the park was the Mountain Scenic Railway. The roller coaster ride was considered to be the longest ride of its kind in America, running some 2.5 miles. In 1934 the ride was renamed the Alps, and in 1939 the track layout was redesigned. The profile of the mountain was a defining feature of the park.

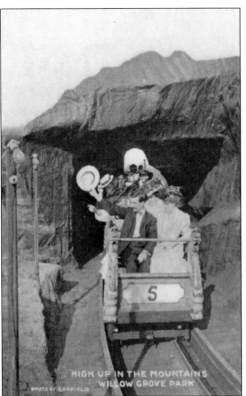

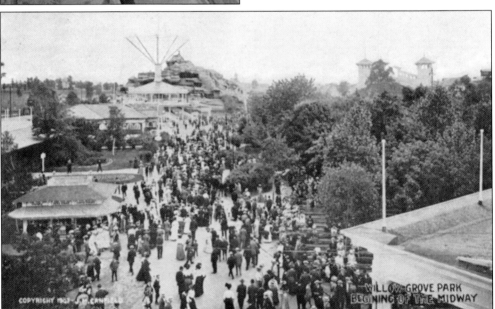

The Midway was the main thoroughfare of amusement rides in the park. A merry-go-round, a Ferris wheel, several roller coasters, and endless rows of shooting galleries provided every type of diversion for the crowds. Toward the center of the image is the Flying Machine and the Mountain Scenic. In the distance is Venice, a mile-long gondola ride through a re-creation of that Italian city. Beyond was the Coal Mine ride.

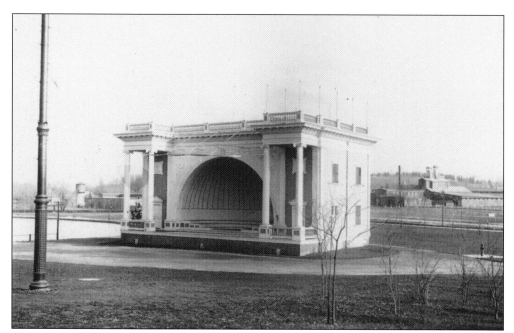

Willow Grove Park was known as the Summer Music Capital of America. The country's best musicians were brought to the park each summer with concerts held at the Band Shell. The concerts were free and the audiences were quite large. In 1900 an adjoining music pavilion was built to shelter the audience, but for the first four years, listeners sat on the open lawns.

Among the most popular performers to appear regularly at the park were John Philip Sousa and his band; Victor Herbert and his orchestra; Walter Damrosch, conductor of the New York Symphony Orchestra; and Arthur Pryor, America's youngest and most brilliant bandmaster. Musical programs featured a mix of the classics, marches, waltzes, and compositions by the popular composers of the day.

The Electric Fountain was one of the most impressive features of the park. Pumping 1,500 gallons of water per minute to heights of 100 feet, the fountain was a study in crystal sparkling water by day and a spectacle by night. It was illuminated from beneath by 15 searchlights shining through heavy glass-colored discs. The fountain, inaugurated on July 4, 1896, cost $100,000 to build.

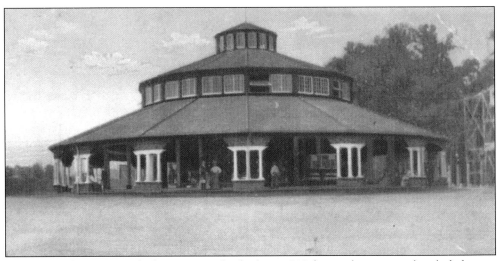

The park had one carousel when it opened, which was 100 feet in diameter and included many fanciful animals for riding. Within ten years a second carousel was added.

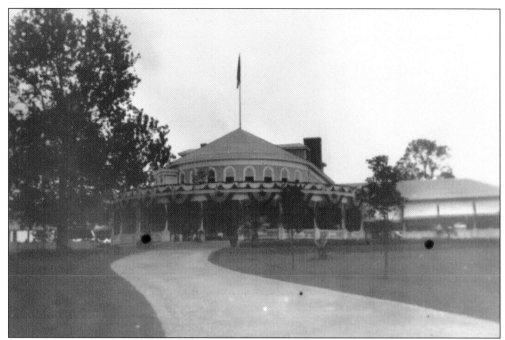

The casino, designed by Horace Trumbauer, was built near the center of the park as a central landmark. The building cost $100,000 to construct, and the restaurant was one of the finest in the area. It had an excellent chef, many polite waiters, and seating for more than 500 people on its broad porches. The restaurant was within listening distance of the concerts.

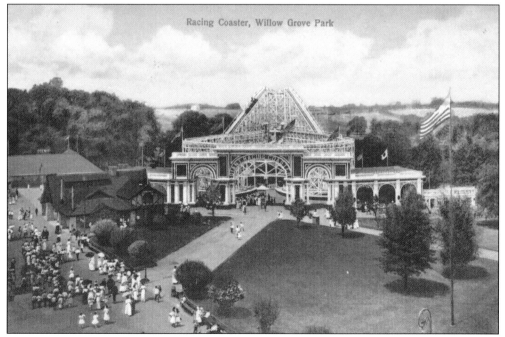

The Giant Racing Coaster, also known as Chase Through the Clouds, was built in 1911 to satisfy the demands of patrons wanting more daring rides. Cars were lifted 100 feet and released downward. The ride was dismantled c. 1931.

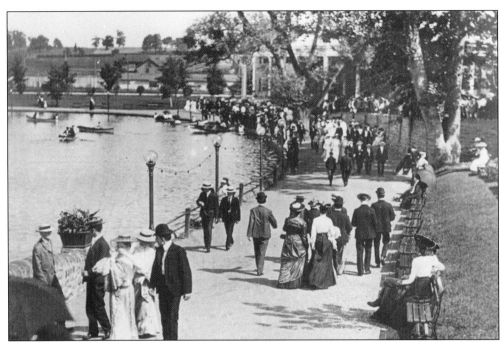

Many people came to the park to enjoy the natural beauty. The park contained a magnificent collection of rare plants, fragrant flowers, and trees. There was a specially heated lily pond that included a large Victoria Regina lily. There were also two lakes for boating, and at night the park became an illuminated wonderland.

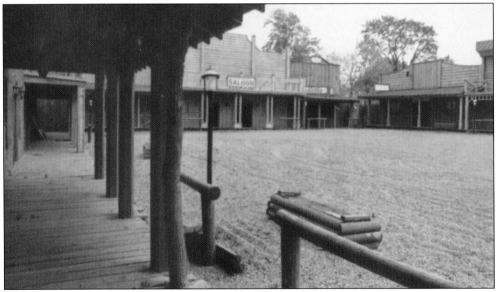

The coming of the automobile and a disastrous fire in 1929 signaled the end of the heyday for the park, although it still operated reasonably successfully for another 30 years. The last trolley ran to Willow Grove in 1958. The old band shell was used for the last time in 1956. Soon after, the two lakes were filled in and a 117-lane bowling alley was built. The park had a brief comeback from 1972 to 1975, as Six Gun Territory, but was closed for good in April 1976. The park was demolished in 1980 for the construction of the Willow Grove Park Mall.

Five

MEADOWBROOK, RYDAL, AND MCKINLEY

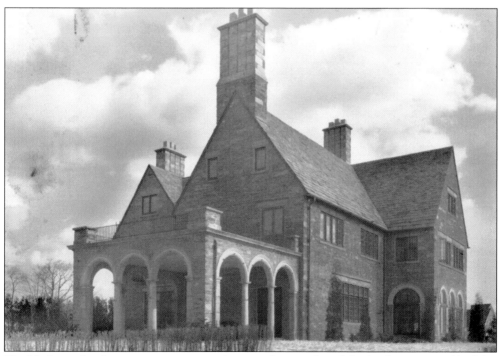

The Herkness family was very active in real estate; they purchased the land once owned by John Wanamaker and developed much of Rydal and Meadowbrook. The home of Alice and John Smylie Herkness sits back from Valley Road. Built in 1920, the house later became a Roman Catholic convent. Today, the building is for sale. The Herkness's daughter Alice married J. Liddon Pennock in 1936. As a wedding present, the couple received a newly constructed house and what is now Meadowbrook Farms.

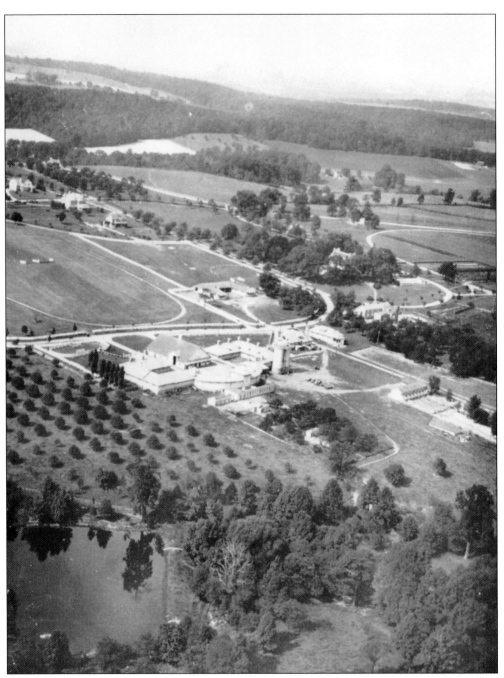

Henry Seybert willed his estate of 300 acres for the formation of a Children's Village, which was established in 1906. The purpose was to provide for destitute children living in the slums of Philadelphia. Existing buildings were adapted and improved, and new buildings were added. A national financial depression in 1915 forced the school to close a year later. The property was sold to Edward E. Marshall in 1917. Many of the buildings were converted to family residences and are still in use today.

Meadowbrook School was founded by area residents in 1919 as a parent-owned country day school for boys from kindergarten through eighth grade. The original site of about 15 acres, including a school building and infirmary, had been part of the former Children's Village. The Reverend John W. Walker was the first headmaster.

Faculty and students from the Class of 1927 assemble for a school photograph. In a 1919 letter to prospective students, founder Rev. John W. Walker states, "The school will combine the latest and most improved methods of instruction together with the opportunity of Country Life for boys during their recreation. The aim of the school will be to give boys such training as will develop equally the mind and body, laying a foundation for perfect manhood in years to come. The moral growth of the boy will also be carefully nourished for the upbuilding of character."

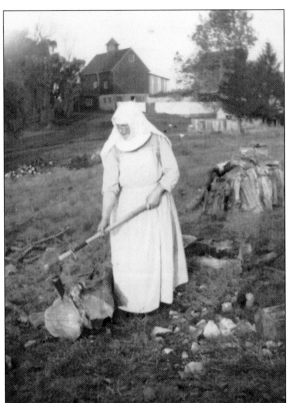

In 1934 a community of the Sisters of the Holy Redeemer, originally from Germany, moved from their base in Philadelphia to a 56-acre farm they purchased on Huntingdon Pike in Meadowbrook. They cleared fields, repaired buildings, and planted crops to help feed those they served. In this 1935 view, one of the sisters chops wood on what is now the Redeemer Village site. The barn in the background still stands on the east side of Huntingdon Pike. The former farm became the site of a new Provincialate on Moredon Road in 1965.

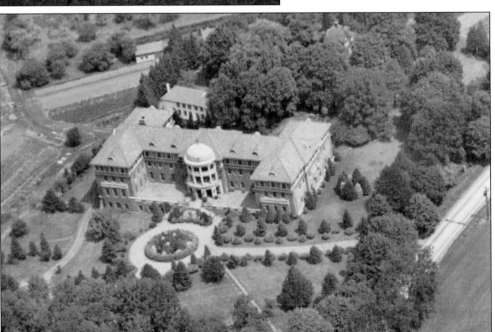

In 1935 St. Joseph's Manor was completed by the Sisters of the Holy Redeemers and became the home of 125 elderly and infirm residents. In 1959 additional buildings were cleared from the site to make way for the first Holy Redeemer Hospital building.

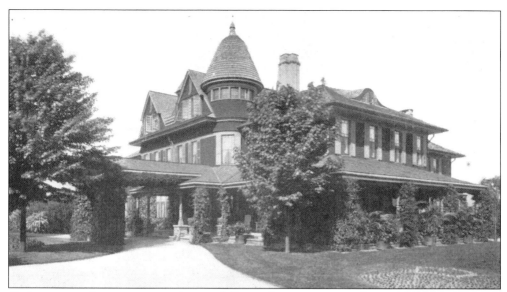

Craigerie was the summer residence of Craige Lippincott, president of J.B. Lippincott & Company and director of numerous financial and philanthropic institutions. In later years, the home was owned by the Meinel family, and in 1948 the Blaetz family purchased the property. When a plan to build a Food Fair on the property fell through, the land was acquired by the Abington School District. The school district sold the property in 2003 for a housing development after area residents failed to raise the funds needed to keep the property as open space.

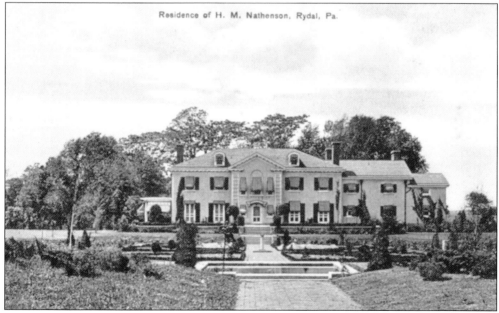

Westwood, the Georgian home Horace Trumbauer built for Henry M. Nathanson c. 1907, was located in the triangle bordered by Susquehanna and Mill Roads and the railroad. Trumbauer elevated the house, providing two terraces. Outbuildings erected with the residence included the stable, the twin farmhouse, and the chicken house. Alterations were made in 1911 and 1920 by the new owner, William O. Lenz. Developers razed the estate in the late 1950s.

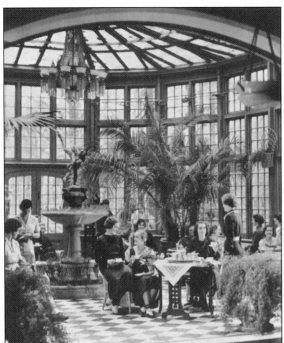

The Ogontz School for Girls began as the Chestnut Street Female Seminary in Philadelphia before relocating to Jay Cooke's Elkins Park estate Ogontz in 1883. In 1917 the school moved to 54 acres of land that had formerly been part of the Hering estate. Sutherland Hall, named after headmistress and owner Abby A. Sutherland, was the center of school life; the Palm Court (solarium) of the building was the setting for afternoon tea. After a century as one of the leading schools in the nation, Ogontz was dissolved and its buildings were donated to Pennsylvania State University.

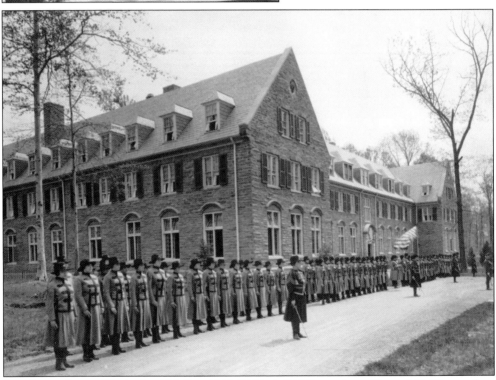

Standing in front of Sutherland Hall in 1918, "Abby's Girls" practice military drill. The student body expanded from 100 to 175 with the construction of Sutherland Hall, a Georgian structure designed by noted architect Horace Trumbauer. The school's landscaping was designed to give the atmosphere of a "home estate." The duck pond remains today as a legacy from that period.

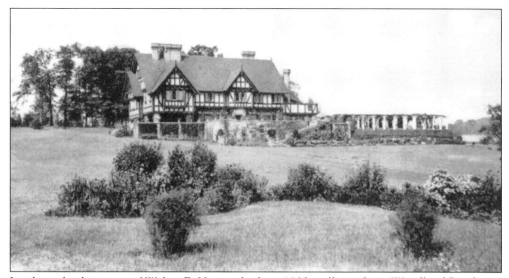

Lyndanwalt, the estate of Walter E. Hering, built in 1903, still stands on Woodland Road near Huntingdon Road. Hering was the founder and president of the Globe Ticket Company, the world's largest producer of theater tickets and streetcar transfers. Hering added a swimming pool and pool house in 1917 on plans by Horace Trumbauer. The house, built in the Tudor style and originally designed by Oswald C. Hering, was later modified by subsequent owners, Mr. and Mrs. Miles Fisher. Throughout the 1980s and 1990s later owners of the property sold most of the land surrounding the main house for development.

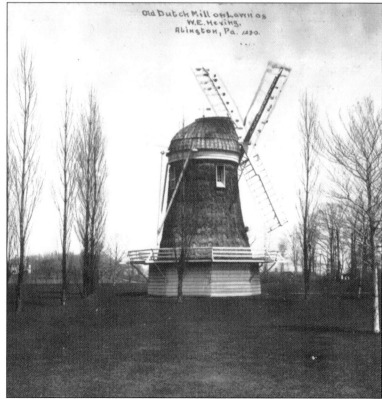

The Old Dutch Mill stood as a landmark along Huntingdon Road on the estate of W.E. Hering. The genesis of the windmill is unclear, but it was demolished in 1985 to make way for new homes built along the western perimeter of the property.

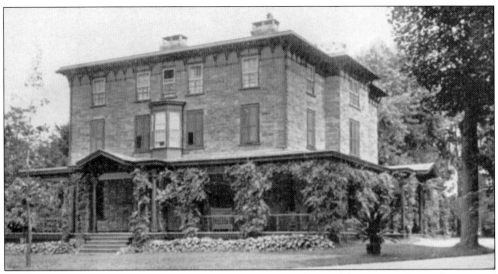

Avila, the country home of William West Frazier, was located between Meetinghouse and Susquehanna Roads and Washington Lane. Built on land purchased by Frazier in 1876, the mansion was one of three adjoining Frazier family-owned estates; the others were Chelten and Tockington. Frazier made his fortune in the sugar-refining business.

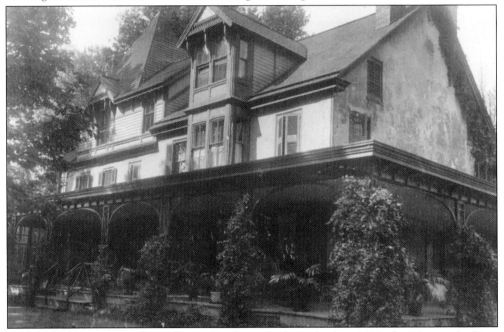

Tockington, located on Meetinghouse Road, was built in the late 1600s for Thomas Jenkins. The original one-room farmhouse was greatly expanded and modified over the years; the main old house had been erected in the 1720s or 1730s. Celebrated gardens were laid out in 1740, with boxwood hedges imported from England. Horace Trumbauer designed Victorian alterations, including a porch, for the estate in 1906, for W.W. Frazier (as shown). The house was later restored it to its original Colonial style. In 1939 Howard Wolf acquired the property and maintained it until the late 1990s, when it was sold and much of the grounds, including the elaborate gardens and the outbuildings, were cleared for development.

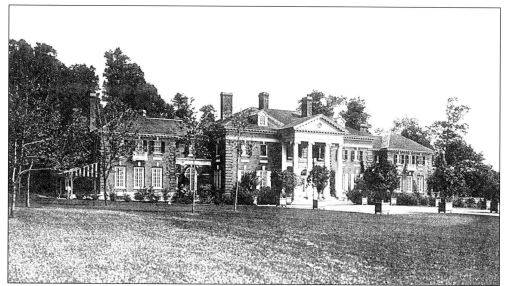

Crosswicks was the 360-acre estate of Clement B. Newbold bordered by Fox Chase, Meetinghouse, and Susquehanna Roads. The mansion was designed by Boston architect Guy Lowell and was one of the largest examples of Georgian English residential architecture in the country. In the 1930s it became the home of Crosswicks Country Club, a 140-acre site that included the Newbold formal gardens with its famed box hedges, rose garden, and lily pond. Crosswicks Farms was developed around the same period on another portion of the estate. The half-timbered Tudor-style homes still stand along Meetinghouse Road. Major development of the property took place in the 1950s after the mansion burned.

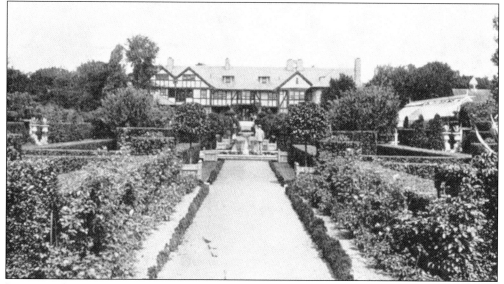

Fairacres, the private residence of John Worrell Pepper, president of the Philadelphia Savings Fund Society, was built in late 1886. His property between Washington Lane and Meetinghouse Road was developed with a large stucco and stone house and formal gardens, all designed by Wilson Eyre. The 37-acre estate was sold in 1937. While most of the property was cleared for development, some garden walls and the end of a colonnaded terrace with its gazebos still stand as a reminder of the Pepper era.

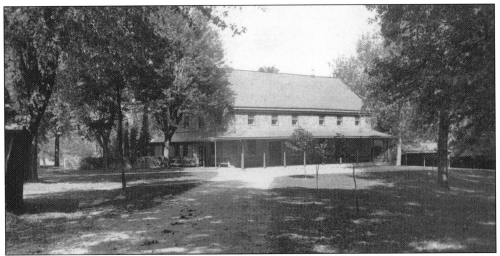

The Abington Friends Meetinghouse, pictured here in 1900, is made up of the second and third buildings on the site. The first small one-story building was completed by 1700. It was replaced in 1786 by the east half of the present building. In 1797 the west half was completed. The establishment of the meeting was made possible by John Barnes, a wealthy English tailor, who allotted 120 acres of his land in 1697 toward erecting a meetinghouse for Friends and maintaining a school under the direction of the Abington Monthly Meeting.

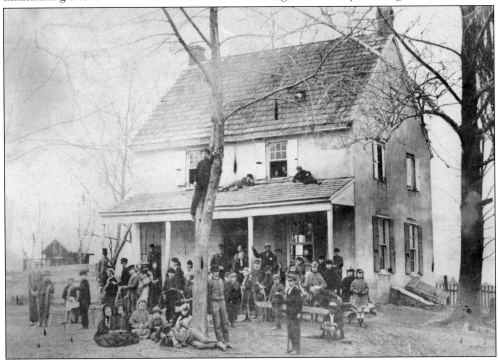

The first Abington Friends School was held in the meetinghouse up until the construction of a separate small building, shown here in 1865. Completed in 1784, it housed the school for 103 years. The building still stands as the present-day caretaker's house, adjacent to the meetinghouse. Abington Friends School served for more than a century as the only school in the Old York Road area.

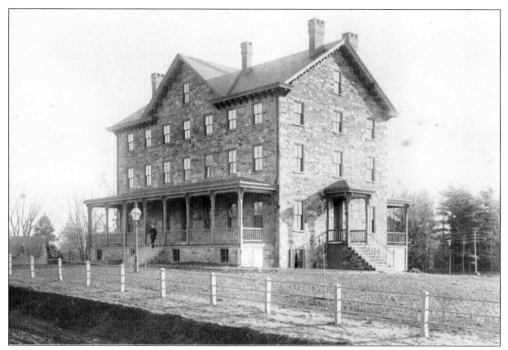

The second Abington Friends school building, Harrison Hall, was added in 1887. Pictured in 1912, it was sometimes called "the Triangle Building" because it was built on a triangular piece of land bordered by Jenkintown and Meetinghouse Roads and Greenwood Avenue.

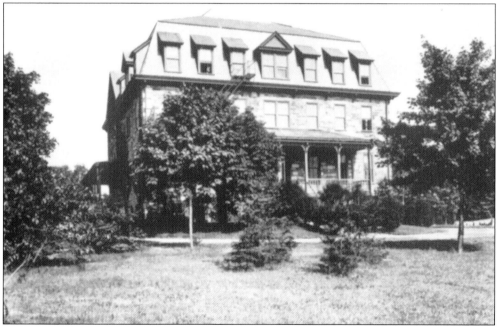

In 1890 an additional school building was added to the triangle property. By 1891 the kindergarten through twelfth-grade school opened by Edith W. Atlee, a Quaker minister, had 50 boarding students, 100 day students, and 8 faculty members. Both buildings on the triangle property were demolished in the 1970s.

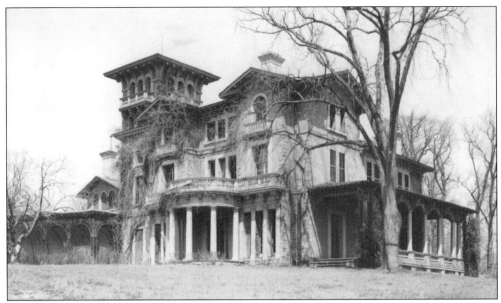

When Joshua Francis Fisher moved from South Carolina to his estate on Meetinghouse Road, formerly part of the Phipps property, he had architect John Notman design the first Alverthorpe. The house, pictured in 1925, was completed in 1850. It was the residence of the Fisher family until it was purchased in 1937 by Lessing Rosenwald, head of Sears, Roebuck & Company. Rosenwald demolished the house and built a 52-room manor, designed by architect Ernest Grunsfeld of Chicago. The manor was built with special systems to house his world-famous collection of early manuscripts, prints, and rare books.

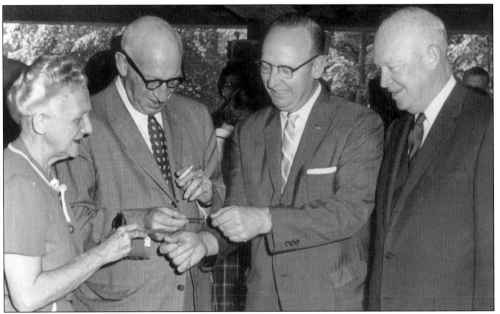

Edith and Lessing J. Rosenwald receive their park identification cards from William Yost, president of the Abington commissioners, while personal guest, former Pres. Dwight D. Eisenhower, looks on. The preview of Alverthorpe Park was held before the official dedication on May 26, 1962.

108

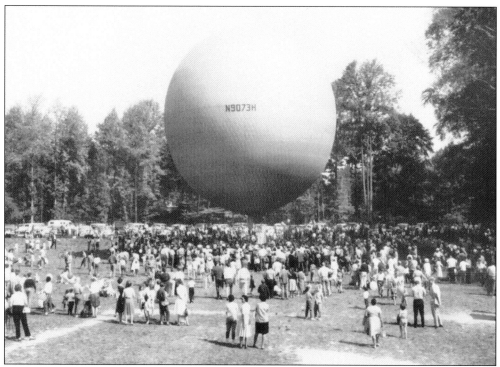

Edith and Lessing J. Rosenwald donated 54 acres of their property to be developed into a township park. More than 25,000 residents attended the first Alverthorpe Park Day, sponsored by the Friends of Alverthorpe Park, in September 1964. The celebration featured a natural gas balloon, radio and television personalities, bike races, midget football, and an ox roast. After Lessing Rosenwald's death, the manor house became a cultural center for Abington residents.

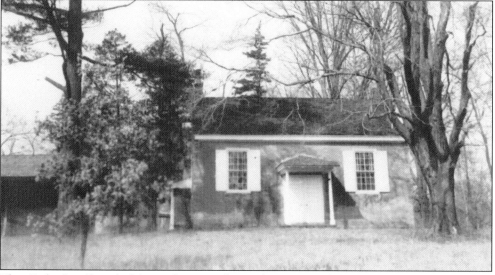

The Orthodox Friends Meetinghouse still stands as part of the Alverthorpe property on Jenkintown Road. In September 1827, 19 members of the Abington Monthly Meeting withdrew, choosing to establish their own meeting. The schism was known as the Hicksite Separation. The Orthodox Meetinghouse was built in 1836.

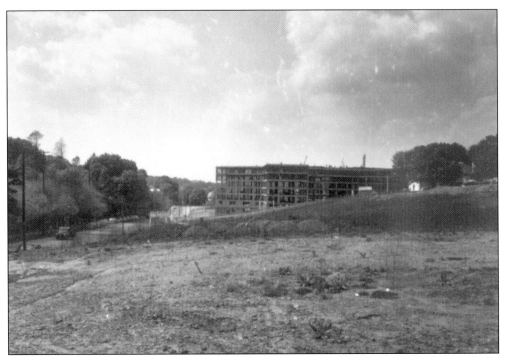

The construction of the Benson, the first apartment high rise in the area, took place in 1954. The building occupies the west side of the former Mary B. Warburton estate, Rosemary, which extended along Township Line Road between Old York Road and Washington Lane. The developer, William Fox, later added another building fronting on Old York Road.

Looking north on Old York Road from Township Line Road reveals the absence of development, c. 1942. The future Benson East site is on the left, and the Old York Road Country Club, founded in 1910, is on the right. Part of the county club property was developed in the 1960s; Lord & Taylor was built in 1964, followed in 1967 by the office and retail space now called the Pavilion. The house on the right still stands at the corner of Lenox Road.

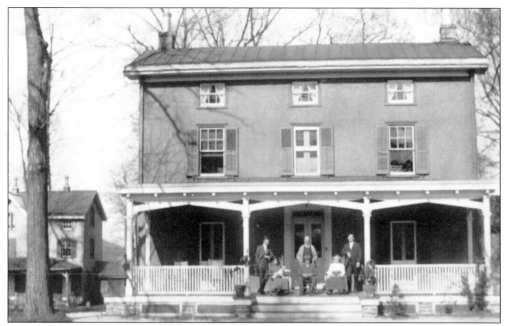

The James Hulton family, pictured c. 1915, purchased a 5-acre tract at the corner of Jenkintown Road and Forrest Avenue in 1906. The property included two homes and a barn. In the early 1980s, when the property was sold, the house on the left and the barn were demolished to make way for development. James Hulton was founder of Hulton Dyeing Company.

This 1940s view looks east down Jenkintown Road toward McKinley. The sign on the right advertises new homes being built on Huron Avenue. Eddie's Store is on the left at the corner of Tulpehocken Avenue.

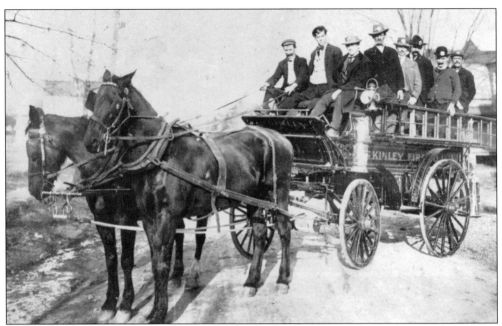

The McKinley Fire Company No. 1 was organized in 1906 following a disastrous 1905 fire in the town. A service wagon was procured in 1907, and in 1908 the first firehouse was built on Cadwalader Avenue. Clement Newbold donated the first motor-driven fire truck in 1914.

In 1918 this larger firehouse was built in front of the original building. It served until 1953, when a split-level firehouse was built at the corner of Jenkintown Road and Cadwalader Avenue. The building, dedicated on January 26, 1954, served the fire company until the need for larger quarters caused the company to relocate across the street in 1973.

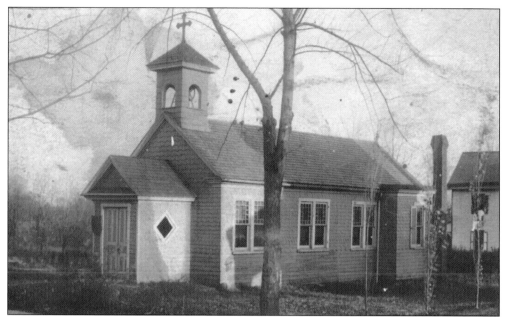

St. Andrew's Chapel was started *c.* 1900 as an outreach of the Church of Our Savior, Jenkintown. The building was erected before 1909 at Jenkintown Road and Ogontz Avenue. At first, it was ministered to by local clergy. It later became a Diocesan Mission, and for several years students of the Divinity School held services there. The chapel finally closed *c.* 1923.

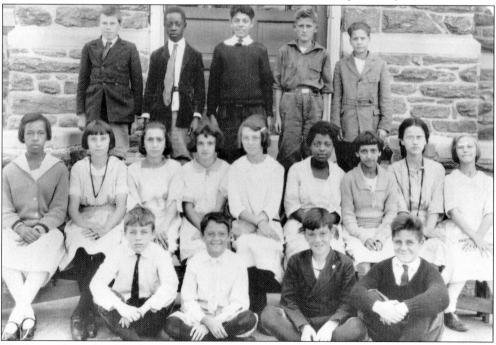

The McKinley School, built on Cadwalader Avenue in 1898, is the only public school designed by noted architect Horace Trumbauer. An 1898 *Times Chronicle* issue described the new school as being modern in every respect, with large amounts of glass in every classroom. Previously classes were held in a small dwelling house located at Cyprus and Cadwalader Avenues.

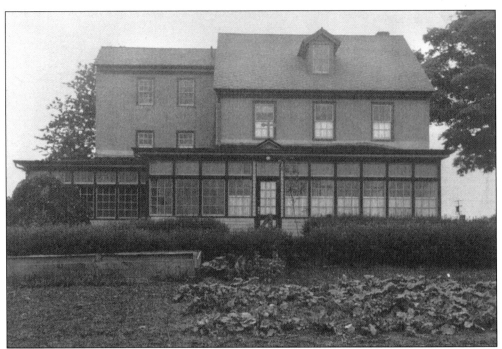

The house built by Abel Satterthwaite Sr. in 1815 is noted for its connection to Betsy Ross. In 1827 Ross moved to Abington to live with her daughter, Susannah, and her family. Later, Edwin Satterthwaite conducted a nursery and a fruit and trucking business on a large scale. The house and the barn, located on Fox Chase Road, still stand on the property owned by the Sisters of St. Basil the Great.

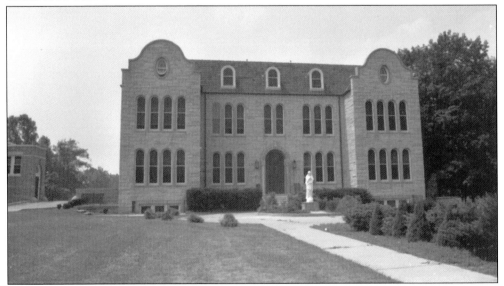

The original St. Basil's Academy building on Fox Chase Road was completed in 1939. The school was established by a group of the Sisters of St. Basil the Great, originally from the Ukraine, who moved the Novitiate and Motherhouse to Fox Chase Road from Seventh and Parrish Streets in Philadelphia. While maintaining an orphanage in Philadelphia, they established St. Basil's Home in 1935, and later the academy. In 1947 Manor Junior College opened.

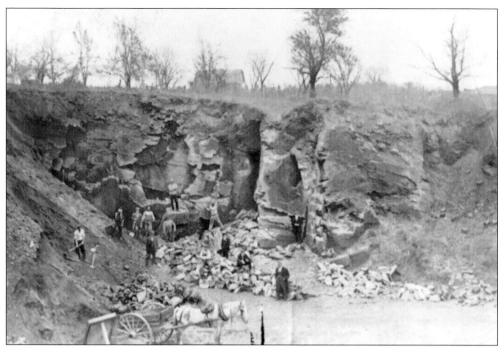

The J. Longstreth stone quarry was located near Shelmire Avenue on one of several pieces of land owned by the Longstreth family.

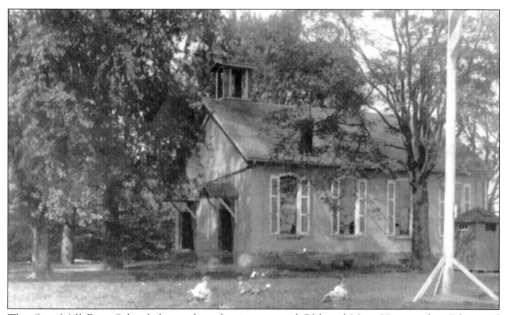

The Saw Mill Run School, located at the juncture of Old and New Huntingdon Pikes and Cedar Road, was one of the oldest schools in the township. The school was formed before the passage of the Free Public School Law in Pennsylvania in 1834. The second school building, pictured here, was constructed in 1873. It was later purchased by the Bethel Baptist Church from the School District and incorporated into the church's building.

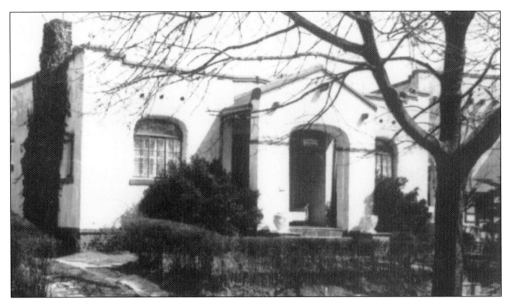

In the 1920s, Gustav Weber, a California builder, constructed a 120-unit housing development with a southern California flair called Hollywood. Located between Fox Chase Road, Cedar Road, and Huntingdon Pike, the development had streets named after California cities. The landscaping included California trees and plants, which soon died off because of the climate. In the center of the community was a small business area with a grocery store and several stores that are still standing. The single homes sold quickly for sums of $4,000 to $5,000.

Hollywood Tavern, pictured in 1946, was the original sample house for the Hollywood development. Although the building remains, the tavern was altered shortly after it was purchased in 1946 by the Reichelt family, who operated the establishment until 1973.

Six

ROCKLEDGE

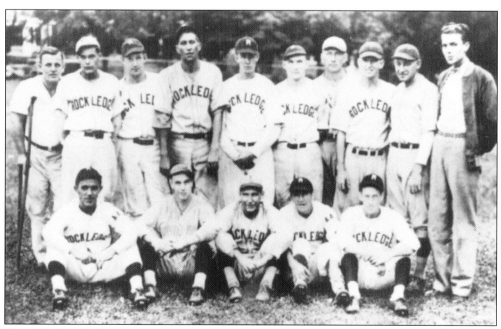

The 1934 Rockledge championship baseball team appears here, from left to right: (front row) Allen Keightly, P. Young, Doug Berry, C. Evans, and L. Shirley; (back row) Billy Walters, W. Stafford, H. Coley, Norman Sophi, W. Joule, P. Mathers, Charles Sophi, Ken Berry, Harry Rath, and Ed Montanye.

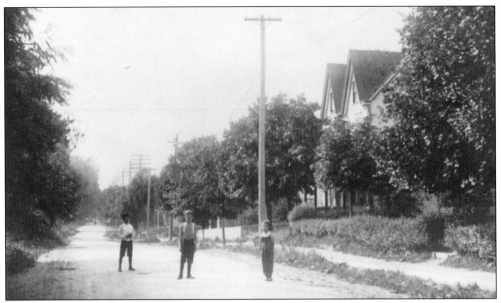

This image was taken *c.* 1910, at Sylvania Avenue, looking northwest on Huntingdon Pike. In 1846, Huntingdon Pike was known as the Middle Road, since it was located between Bustleton Pike and Old York Road. In the same year, a charter was granted to the Fox Chase and Huntingdon Turnpike Road Company, thus giving the name by which the road is known today.

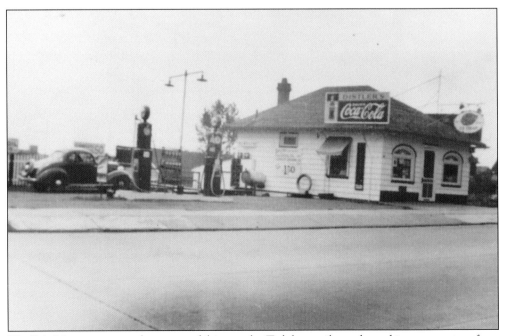

"Pop" A. Nonneman was the owner of this popular Tydol gas, oil, candy, and ice-cream store from the 1930s to the early 1950s. The establishment was located on Huntingdon Pike at Fox Street.

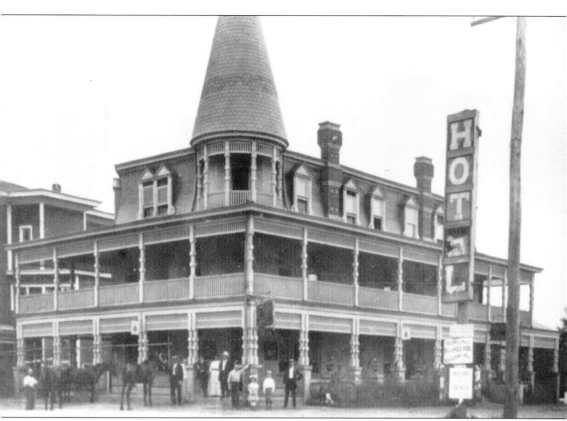

The Rockledge Hotel was situated on Huntingdon Pike at Fillmore Street, at the border with Fox Chase, Philadelphia. Constructed early in 1895 by owner George H. Brown, the hotel opened July 4, 1895, with much fanfare, free refreshments, and an evening fireworks display. Part of the building served as an opera house until that section burned down in the early 1900s. During the final years of World War I, the hotel was used as a recreation and recuperation center for men in the U.S. Navy. Around 1923, the Northeast Shrine Club purchased the property and used the building and grounds for various Masonic and other community functions. They held an annual circus on the grounds and provided a baseball field for the use of semiprofessional and Little League baseball teams. In 1986 the property was sold to the Cheltenham Bank to make way for a new building. Demolition took place in 1989.

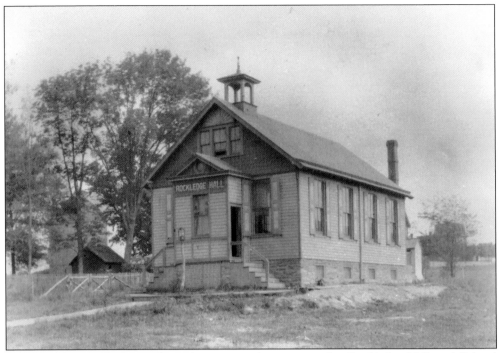

In 1888 a group of citizens formed a new stock company, the Rockledge Hall and School Company, and purchased ground on which to build this two-room school. Located at the northeast corner of Huntingdon Pike and Robbins Avenue, the school opened on February 11, 1889, with Miss Bernhard as teacher and 25 students.

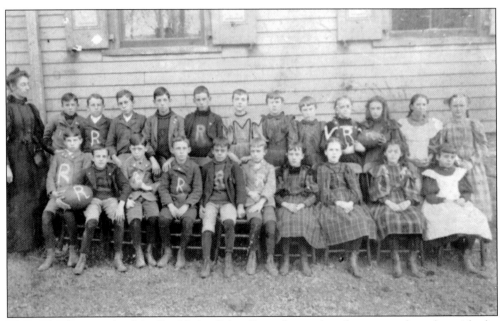

This early photograph of the Rockledge School's teacher and students was taken alongside the original school building. On December 9, 1902, the school burned to the ground. Classes soon resumed in the Parish Hall of the Memorial Church of the Holy Nativity.

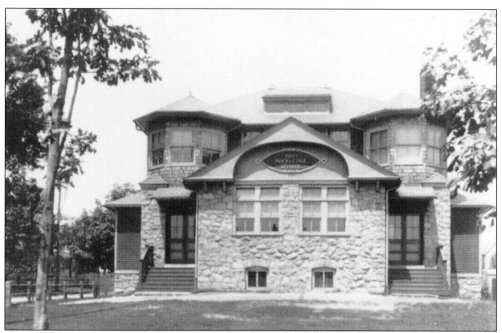

The new stone school building opened in September 1903, replacing the frame school lost in the fire of 1902. The new school was much larger and was built at the same location at the corner of Robbins Avenue and Huntingdon Pike. Four additional rooms were constructed in 1917. In 1977 the school closed.

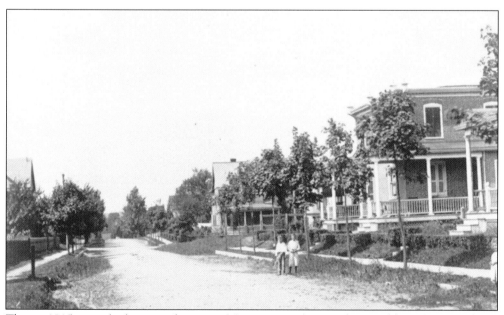

This *c.* 1915 view, looking northwest up Montgomery Avenue from Robbins Avenue, shows homes typical of the many residences built in Rockledge. These homes were built on lots purchased from the Fox Chase Land Association, one of the major developers of Rockledge.

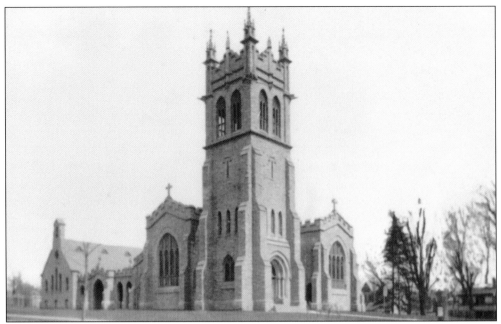

As early as 1883, Episcopal communion was held in Rockledge under the supervision of Rev. Henry Hoyt, rector of Trinity Church, Oxford. A parish was established in 1893, and shortly thereafter a stone building was erected. In 1899 the Memorial Church of the Holy Nativity was consecrated, being a memorial to Robert W. Ryerss. The original building was moved back on the property and became the parish house. Fordwyce H. Argo was the first rector appointed in 1898, and served until his retirement in 1943.

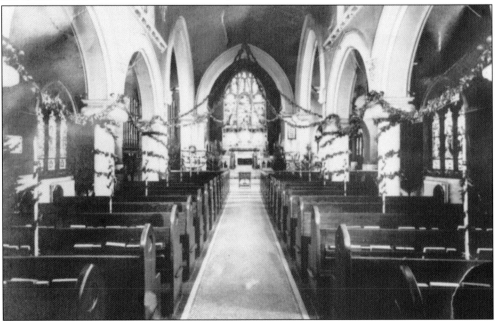

The nave of the Memorial Church of the Holy Nativity is shown decorated for Christmas in 1941. The interior of the church has remained much like it was originally designed, except for the addition of a baptistry in 1924 in memory of Mrs. Ryerss.

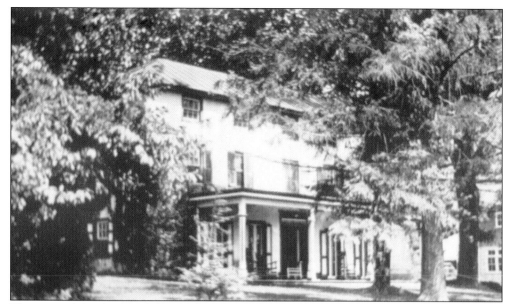

The original farmhouse of the Robbins family, built *c.* 1840, was purchased by the Memorial Church of the Holy Nativity in 1898. The house was used as the rectory until 1925, when it was removed and replaced by the current house in the same location on Huntingdon Pike.

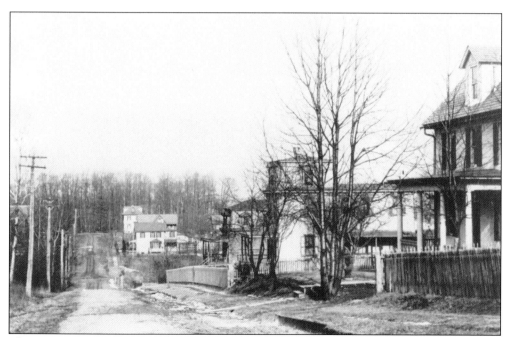

This *c.* 1915 view looks northeast on Jarrett Avenue from Valley Street.

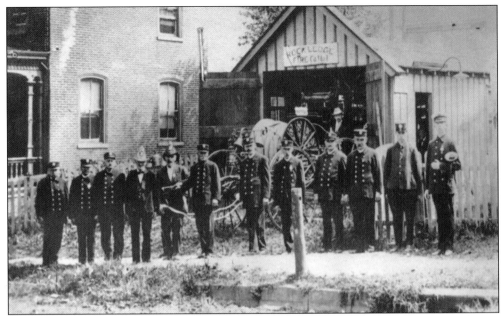

The Rockledge Volunteer Fire Company No. 1 was organized in 1903 after the Pennsylvania Fire Company No. 1 in Fox Chase disbanded. The company built a temporary firehouse that year to house the ladder truck received from Fox Chase. In front of the first firehouse on Sylvania Avenue are Frank Wise, Sam Hipwell, John Campbell, Charles Bartle, Charles Mortimer, Emiel Nurnberg, George Russell, Max Silverman, Billie Roberts, Andrew Getz, Bill Jones, and Jacob Witmer (order uncertain).

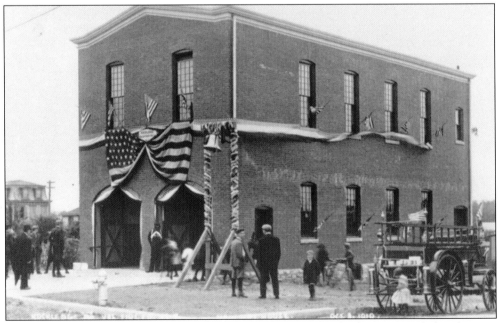

In 1910 the shareholders of the fire company decided a better facility was needed and a new building was opened on Huntingdon Pike at Park Avenue. The firehouse served the volunteers until they built their present building next-door at 505 Huntingdon Pike in 1953.

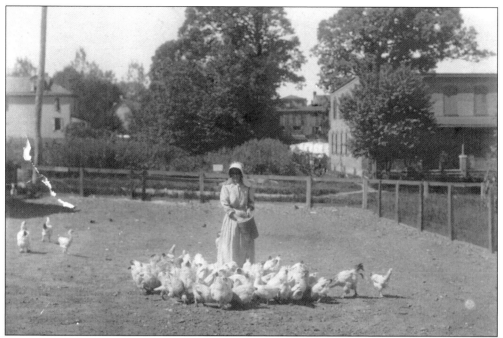

Mary Elizabeth Hipwell, wife of Samuel T. Hipwell, feeds the chickens behind her residence at 15 Sylvania Avenue, c. 1903. The land extended back to Park Avenue. The house on the left in the distance was the Jones house, which stood on Huntingdon Pike across from the tollhouse. The 1910 firehouse was built between the Hipwell and Jones properties.

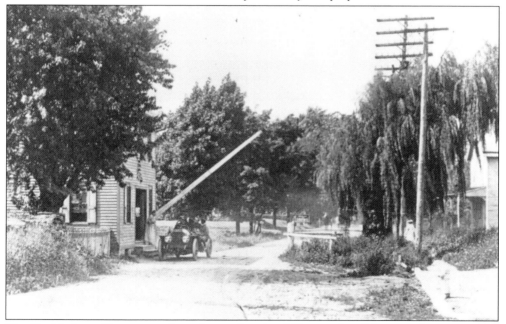

The Rockledge tollhouse stood on the south side of Huntingdon Pike near the present-day entrance to Lawnview Cemetery. Tolls were collected by the Fox Chase and Huntingdon Turnpike Company. When the state took over maintenance of the road in the 1920s, tolls were no longer collected. The building was moved to 208 Central Avenue in 1935.

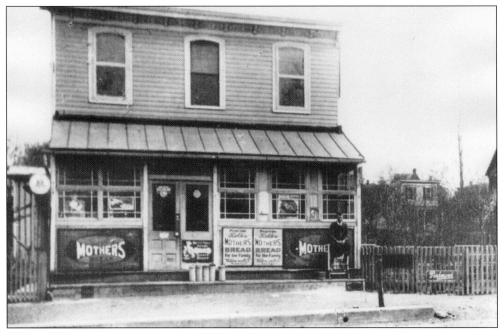

King's General Store was located at the corner of Park and Montgomery Avenues. The store also served as the Rockledge Post Office *c.* 1900. The photograph dates from the 1920s.

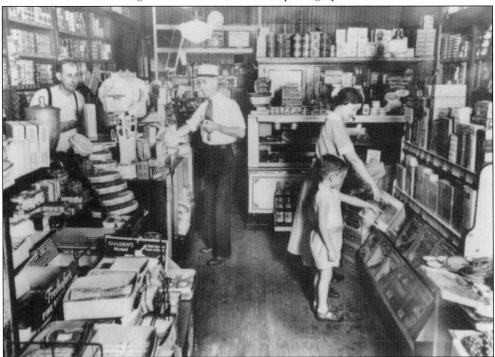

Charles H. Strech owned this grocery and butcher shop at the corner of Montgomery and Park Avenues in the 1930s and 1940s. After World War II, his son-in-law, Ray Grap, took over. The shop was a wonderful place for kids to buy candy and "caps" (for cap guns) in the 1950s. Grap had the patience of a saint.

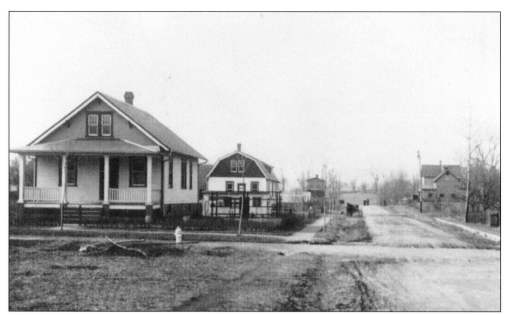

This 1915 view looks west on Montgomery Avenue at the intersection of Central Avenue. The house in the foreground is 45 Central Avenue with John Sheppard's house behind.

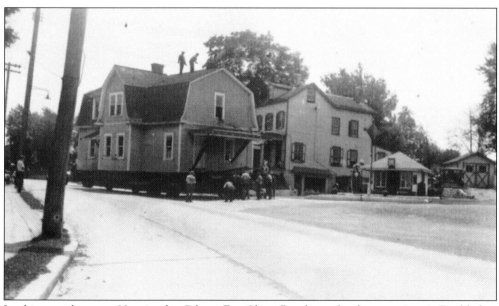

Looking southeast on Huntingdon Pike at Fox Chase Road, another home arrives in Rockledge. The house is coming from its original site on Fox Chase Road across from Alvethorpe Park to its present location at 150 Elm Avenue.

ACKNOWLEDGMENTS

The Old York Road Historical Society is honored by the invitation of Arcadia Publishing to compile this book of the history of Abington Township, Jenkintown, and Rockledge. Such an effort could not have been successful without the dedicated efforts of those who comprised the Old York Road Historical Society's book committee: Frank Ames, Arlene Hackman, Wani Larsen, Joyce Root, David Rowland, David Seitz, and Robert Singer. Joyce Root, the Old York Road Historical Society archivist and librarian, was invaluable throughout all phases of the project; she coordinated images and researched sizable portions of the text. In addition, society members Mary Washington and Dan McCormick assisted at critical junctures in the process.

The cooperation and hospitality extended to the Old York Road Historical Society as we searched for images and information is most appreciated. This publication effort was truly a community endeavor. Valuable assistance was provided by the following: Emily Anders, Ellen Bard, Elva Bell, Tom Cameron, Donald Clark, Leon Clemmer, Fred Conti, Joseph Conti, John Deming, Mike Gillespie, Hank Haines, Andrew Herman, Samual and Margaret Hipwell, Jerome Holst, Sr. Mary Cecilia Jurasinski, William Kelly, Bob Lee, Walt Lufkin, Rosalie Martz, Tom McNamara, Allen Mitchell, Kelly Mosteller, Sr. Martina Nicklaus, Thomas Nyman, Mike Powers, Marie Raabe, Sally Reintz, Myrtle Ryan, Evelyn Short, Bill Shriver, Lesley Singer, Terrie Smith, Joyce Stahl, Pat Stopper, Joyce Tighe, Roger Volland, Nancy Walsh, Doug Wendell, and Millie Wintz.

The Old York Road Historical Society extends its heartfelt thanks to those individuals and institutions that loaned images for inclusion in the book. In addition to the various photographic collections of the Old York Road Historical Society, images have come from the following individuals and organizations: Abington Friends Meeting and School, Abington High School, Abington Presbyterian Church, Abington Township (Department of Engineering, Department of Parks and Recreation, Police Department), Frank J. Ames, Sisters of St. Basil, Joseph L. Conti, Mr. and Mrs. Michael Colino, John H. Deming Jr., Dr. Alan M. Dorfman, Mrs. Albert Eberle Jr., First Union Corporation, Joseph Fitzgerald, Robert M. Harper, Robert E. Hibbert, Mr. and Mrs. Samuel Hipwell, Sisters of the Holy Redeemer, William E.R. Lybrand, Thomas McNamara, Meadowbrook School, Allen Mitchell, Frank J. Neumann, Penn State Abington, Robert Pye, Marie Raabe, Frederick E. Reichelt, Myrtle E. Ryan, Harley A. Shriver, Joyce L. Tighe, and J.B. Winder & Company.